IMAGES
of America

DORCHESTER
VOLUME II

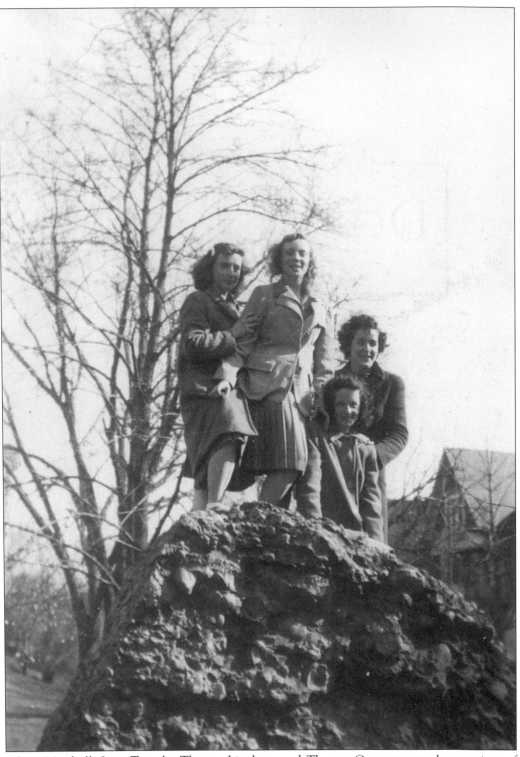

Eileen Mitchell, Jean Temple, Theresa Linehan, and Theresa Corcoran stand on a piece of Roxbury pudding stone at Savin Hill Park in 1946.

IMAGES
of America

DORCHESTER
VOLUME II

Anthony Mitchell Sammarco

ARCADIA

First published 2000

Published by Arcadia Publishing,
an imprint of Tempus Publishing, Inc.
2 Cumberland Street
Charleston, SC 29401

Printed in Great Britain.

Library of Congress Catalog Card Number: 95-237159

For all general information contact Arcadia Publishing at:
Telephone 843-853-2070
Fax 843-853-0044
E-Mail sales@arcadiapublishing.com

For customer service and orders:
Toll-Free 1-888-313-2665

Visit us on the internet at http://www.arcadiaimages.com

*In memory of Eileen P. Mitchell,
fondly known as "Auntie I"
(1929–1997)*

...TENTS

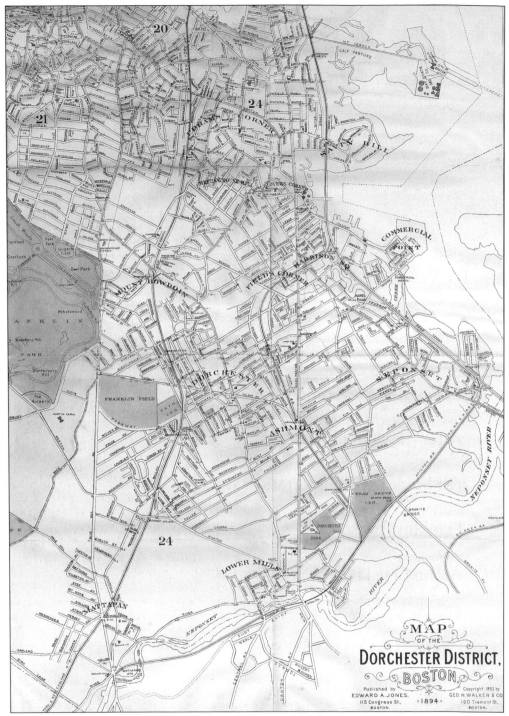

This "Map of the Dorchester District" was drawn in 1894, 24 years after the town was annexed to the city of Boston. On January 4, 1870, the town had a population of 12,000; Dorchester experienced such tremendous growth and development that the population neared 100,000 by the end of the 19th century.

INTRODUCTION

This second volume on Dorchester, Massachusetts, was written in regard to the overwhelming response to the first book, which appeared in 1995. It is gratifying to realize that there is a sustaining interest in the history and development of Dorchester, and in this new book I have striven to include aspects of local history that have not previously been covered in depth. I hope that you will enjoy this history and its poignant and often rare photographs and that you will assist me in continuing this series by sharing your photographs and memories with me.

Founded in 1630, Dorchester remained a rural country town for the next two centuries. However, by the July 4, 1855 celebration commemorating the anniversary of the American Revolution, Edward Everett (1794–1865), the great statesman, orator, and native-born son, delivered a speech to the assembled town residents that made pointed references to the anticipated changes that would sweep Dorchester in the next five decades. Everett said that "there are few places, within my knowledge, which within 50 years have undergone greater changes than Dorchester. The population in 1800 was 2,347; in 1850 it was a little short of 8,000. What was then called the Neck [South Boston], the most secluded portion of the old town, although the part which led to its being the first pitched upon as a place of settlement, was in 1804 annexed to Boston; and being united with the city by two bridges, has long since exchanged the retirement of a village for the life and movement of the metropolis. The pickax is making sad ravages upon one of the venerable heights of Dorchester; the entrenchments of the other, no longer masking the deadly enginery of war, are filled with the refreshing waters of Cochituate lake. New roads have been opened in every part of our ancient town, and two railways traverse it from north to south. The ancient houses built before the revolution have not all disappeared, but they are almost lost in the multitude of modern dwellings." The changes occurring in Dorchester in the years previous to 1855 were eclipsed in the next five decades—as this book illustrates.

For Everett to make pointed reference as to how much Dorchester had changed in 225 years since it was settled by the Puritans was testimony to the great advancements already taking place. With the continued ease of transportation, the Old Colony Railroad and the Midlands Branch of the Boston, Hartford & Erie Railroad traversed Dorchester with depots opening for commuters who worked in Boston, but lived in the country town of Dorchester. In 1856, the Metropolitan Street Railway commenced a horse-drawn streetcar that operated along Dorchester Avenue, connecting the Lower Mills with town; by the beginning of the 20th century, the streetcars that serviced Dorchester created a web of lines that further allowed

residential development for the newcomers. In 1870, the population of Dorchester was just over 12,000, and the annexation was the impetus for growth. The proponents of annexation, led by Marshall Wilder, Samuel Downer Jr., Edmund Tileston, William Pope, Franklin King, and William Coffin, saw the annexation of Dorchester to Boston as an important and inevitable step, as "annexation will give us a larger and more efficient police . . . better arrangement of highways, projected on a scale comporting with the present and prospective wants of a great city. It will open to us all the valuable educational institutions of the city. It will benefit those who pay large taxes, in their more consistent assessment and equal equalization. . . . It will furnish an active stimulant to labor of all kinds and lead to the establishment of mills, foundries, and industries of various sorts. We have an abundance of cheap land, which will be sought after by the householders of moderate means. And by annexation we shall avoid a great evil—the possibility of a city organization of our own, to be delivered from which every good citizen should constantly pray."

On June 22, 1869, the annexation vote carried, but only by a slight margin. This special vote in Dorchester had residents casting 928 in favor of annexation and 726 opposed; with a slight majority of 202, the town of Dorchester ceased to exist and on January 4, 1870, became a ward of the city of Boston. Predictably, the annexation of Dorchester caused the rapid commencement of change, so much so that the "values of real estate increased rapidly from 1870 to 1875, which was due to the real estate 'boom' which followed the annexation, inflating the prices of land." During the decade from 1870 to 1880, this new ward of Boston saw tremendous change, with new streets "opened here and there; estates were divided to give increased opportunities for building; and houses sprang up, as if by magic, to meet the demands of the rapidly increasing number of inhabitants. Dorchester, which had been gradually filling up with strangers who were attracted by the numerous advantages offered by the town, during these years added more names to its already long list of residents who could claim it only as the home of their adoption." In fact, so many new residents of multiethnic extraction came to reside in Dorchester that by the early 1900s, the town might literally have been considered a "league of nations." These new residents added an "infusion of new blood; by the introduction of a new, healthy, and vigorous population of the native race."

Today, more than a century after our ancestors voted to annex Dorchester to the city of Boston, our town is a multicolored, multiethnic, multicultural place called home by people of all walks of life. The town's fascinating history has been widened and enriched by its new residents, who contribute to the rich fabric that weaves together the community that we know and proudly call home—Dorchester.

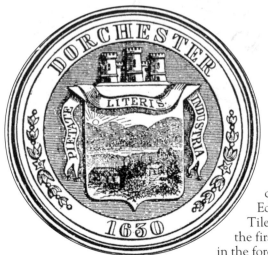

The seal of Dorchester was adopted by the town in 1865 as a device that "would symbolize the acts which rendered the early settlers of this town a peculiar people, and objects of gratitude and veneration by their descendants for all time to come." A committee consisting of Edmund J. Baker, Edmund Pitt Tileston, and Nathaniel W. Tileston proposed a rising sun with the Blue Hills, the first school, and the thatch-roofed meetinghouse in the foreground.

One

BEFORE THE ANNEXATION

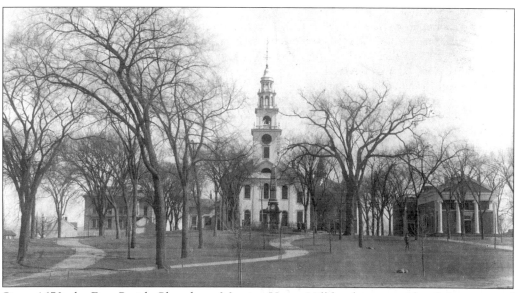

Since 1670, the First Parish Church on Meeting House Hill has been considered the center of Dorchester, with the common in the foreground. Founded in 1630, in Plymouth, England, this church is the oldest religious society in Boston and has a rich and everlasting historical tradition. The church seen here was built in 1816 and was destroyed by a fire in 1896; the present First Parish church was designed by Everett, Cabot, and Mead; it was built in the Colonial Revival style in 1897. On the right is Lyceum Hall, built in 1839; on the left is the Southworth School, now the site of the Mather School. Dorchester Common, used since 1630 as open land, was embellished in 1867 with the Soldiers' Monument in the center. A granite obelisk, donated by members of the Pickwick Club, memorializes those from Dorchester who gave the supreme sacrifice during the Civil War. (Courtesy of John F. May.)

The Humphreys House was built *c.* 1636 at the corner of Dudley and Humphreys Streets, just north of Upham's Corner. Increased in size over the next two centuries, it became hemmed in by the stucco Buckley Moving Company building and was removed in 1917, with portions of the old house being reused for the new house of Rev. Louis Cornish on Fayerweather Street in Cambridge.

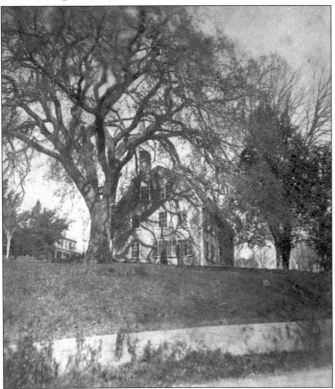

The Robinson Tavern, on the right, stood on Washington Street at the foot of Codman Hill. A popular inn during the 18th century, it was here that the Sons of Liberty met in 1769 and made numerous patriotic toasts, which history records rendered no one even slightly intoxicated. The Codman House, built by Seth Thayer and sold in 1808 to Rev. John Codman (1782–1847), can be seen on the left, the site now flanked by Wilmington Avenue and Ogden Street. It was said that "probably in no private dwelling of the land have there ever been so many doctrinal discussions as in this old mansion house."

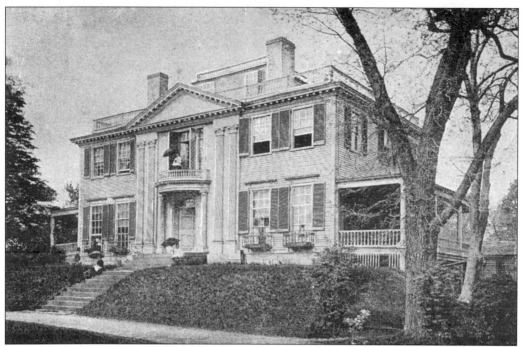

The Morton House was designed by Charles Bulfinch and was considered "by far the finest residence in Dorchester" prior to the Civil War. Built in 1795 as the countryseat of Perez Morton (1751–1837)—speaker of the Massachusetts House of Representatives and state attorney general—at the corner of Dudley and Alexander Streets just north of Upham's Corner, this elegant mansion survived until the late 19th century, when it was demolished for an apartment building. Here, the Mortons "often gathered a brilliant assemblage of men and women famous from their positions in state and society."

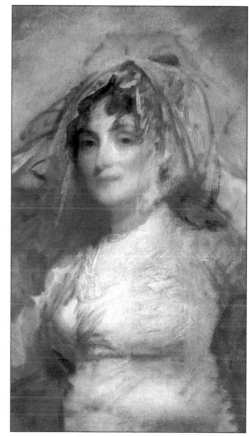

Sarah Wentworth Apthorp Morton (175–1846) was the first cousin of Charles Bulfinch, who designed her countryseat in Dorchester. An elegant and accomplished woman, whose portrait was painted by Gilbert Stuart of which she said "Stuart, thy portraits speak with skill divine." She authored *A Power of Sympathy* in 1789—a scandalous novel of the seduction, rape, and death of her favorite sister—that is considered the first American novel. An able poetess, she was often referred to as the American Sappho and often used "Philenia" as her nom de plume. (Collection of the Worcester Art Museum.)

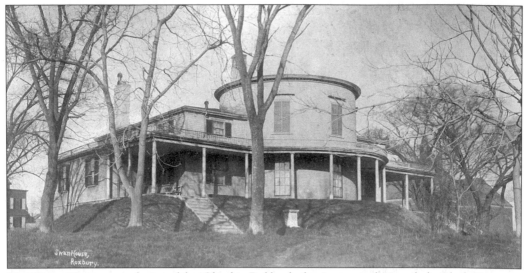

The Swan House was designed by Charles Bulfinch for James and Hepzibah Clark Swan in 1796. Built on a ledge of rocks opposite the Morton House at the present corner of Dudley and Howard Streets, the house was modeled on a French country house and was furnished with Gobelin tapestries, choice objects of furniture, and fine art that were liberated from the royal collections during the French Revolution. In 1825, Madame Swan entertained the Marquis de Lafayette at her estate, reputedly using silver from his estate La Grange that was part of the cache of liberated collections of dispossessed French aristocrats acquired by the Swans.

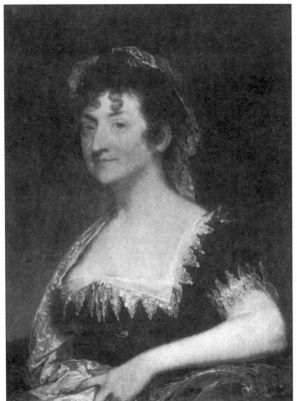

Hepzibah Clark Swan (1776–1825) was an eccentric woman who entertained lavishly at both her Beacon Hill townhouse on Chestnut Street and her Dorchester countryseat. With her friend and near neighbor Sarah Morton, she founded the Sans Souci Club, a fashionable Federal tea assembly where they entertained members of the Boston elite. Her portrait was painted by Gilbert Stuart and shows a confident and fashionable woman of the new republic. (Collection of the Boston Museum of Fine Arts.)

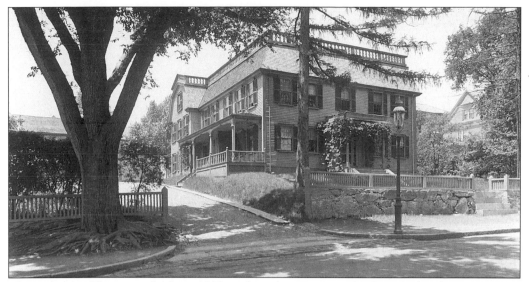

The Robinson House was built in 1788 at the present corner of Adams and Robinson Streets, near Field's Corner. A large house, it was owned by John Robinson, who is reputed to have owned all the land east of Dorchester Avenue at Field's Corner previous to the Civil War. The house was demolished in 1917, when the present New England Telephone Company building was erected on its site. Robinson Street, on the right, was laid out in 1871 and named for the family.

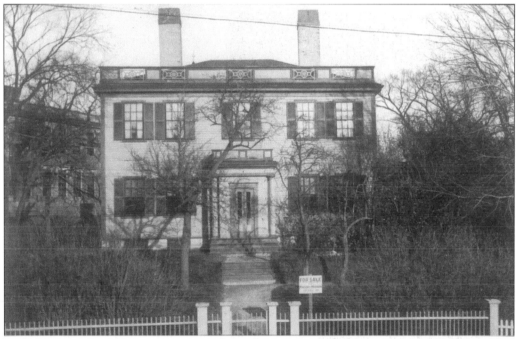

Built by W&F Pope Company as speculative housing in 1804, this elegant house was sold to Judith Saunders and Clementina Beach, who founded Mrs. Saunders and Miss Beach's Academy, a fashionable school for young ladies. Built at the corner of Adams and East Streets, the house later passed to the May family, who lived there until World War I. Today, the Bible Baptist Church worships here. (Courtesy of John F. May.)

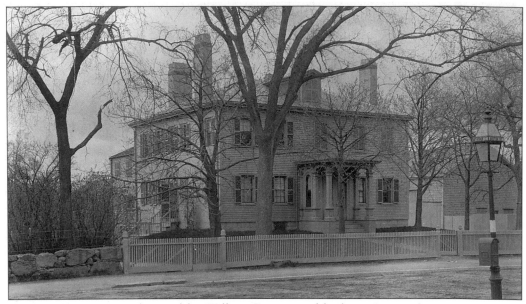

The Clapp House was designed by William Everett and built on Boston Street near Willow Court (now known as Enterprise Street) in 1806. The Clapp family lived on an extensive farm that was granted to them in 1633. The house, referred to as the Mansionhouse by the family, remained in the possession of descendants until 1953, when it became the headquarters of the Dorchester Historical Society, which was founded in 1891 to "preserve, collect, and publish the history of Dorchester." (Courtesy of Frank Cheney.)

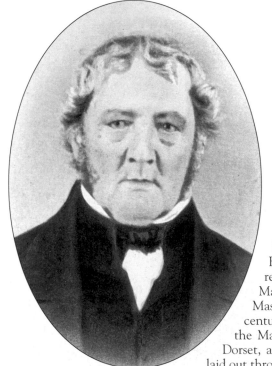

Capt. William Clapp (1779–1860) was a tanner by trade, but with his sons Lemuel, Thaddeus, and Frederick Clapp, he experimented in the hybridization of pears. So successful were the Clapps that their hybridization of the Bartlett and Flemish Beauty pears, the Clapp's Favorite pear, was recognized as a superior pear by the Massachusetts Horticultural Society and the Massachusetts Agricultural Club. In the late 19th century, the names of other hybrid pears, such as the Mayhew, the Mount Vernon, the Harvest, the Dorset, and the Bellflower, were used for new streets laid out through the farm for residential dwellings.

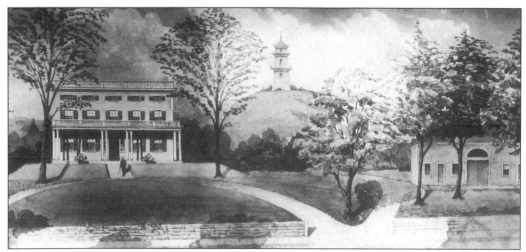

The Macondray House was an elegant Federal mansion that stood on Adams Street opposite Lonsdale and Mallet Streets. Built c. 1810, the estate included a three-story summerhouse, designed to resemble a pagoda, that surmounted Ginger Hill, the western slope of Pope's Hill. Valued at $200 in 1853, this pagoda was a local landmark and was once the scene of lavish parties, as well as the outlook for superb panoramic views of Dorchester.

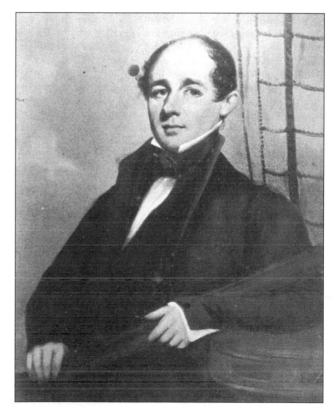

Capt. Frederick W. Macondray (1803–1862) was the supercargo for the China trade firm of Russell & Company. A wealthy sea captain who headed the supply ship *Lintin*, Macondray later sold his estate to Edward King, for whom King Square was named, and moved to San Francisco, California, where he operated the lumberyards of Macondray & Company, which supplied materials for the building boom during the gold rush.

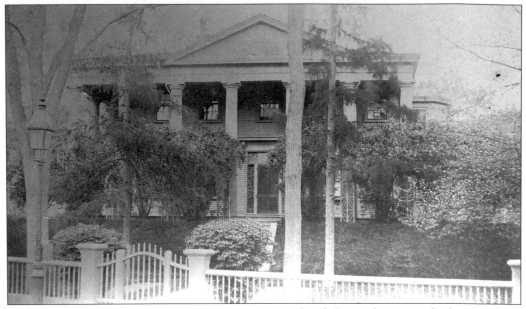

The Oliver-Gardner-Trull House was an impressive Greek Revival mansion built in 1836 by William Oliver, an early vice president of the Massachusetts Horticultural Society, on Hancock Street opposite Trull Street. The owners had extensive gardens on terraces cut into the western slope of Jones Hill, which in later years was developed for houses on Rowell Street. In the late 19th century, the house was purchased by Parkman Dexter, a wealthy developer who subdivided his estate for speculation; it was later owned by developer John Trull.

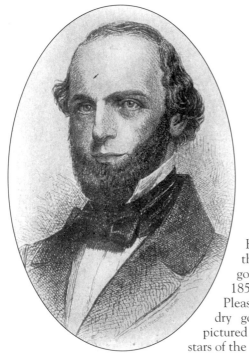

Henry J. Gardner (1818–1892) was an organizer of the Know-Nothing party and was its candidate for governor of Massachusetts, serving from 1854 to 1857. Born at the family homestead on the corner of Pleasant Street and Cushing Avenue, this successful dry goods merchant moved to the grand mansion pictured above, where he entertained the brilliant political stars of the mid-19th century.

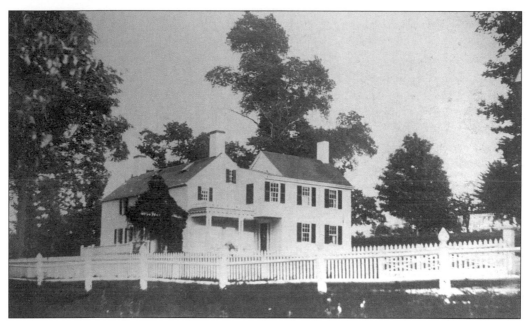

The summerhouse of S.S. Pierce was a 10-acre working farm on Marsh Street (now Gallivan Boulevard), on the present site of St. Brendan's church. Pierce added a series of rooms to this house, which was the family's summerhouse until 1920. After that, the main property was sold to the Archdiocese of Boston and the remainder was developed for residences on newly laid out streets, which included Lennoxdale, Myrtlebank, Rockne, and Crockett Avenues, Milton Street, and St. Brendan Road.

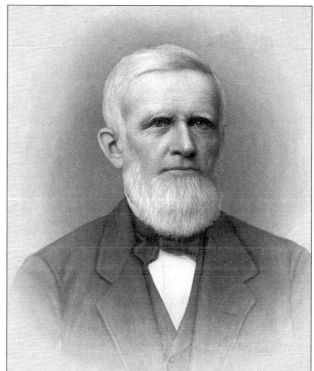

Samuel Stillman Pierce (1807-1881) was born on Adams Street in Cedar Grove. In 1831, he founded a general store in Boston at the corner of Tremont and Court Streets that swiftly became the leading purveyor of fine gourmet foods to Victorian Bostonians. He was known as S.S. Pierce (pronounced "purse") and four generations of the family provided unparalleled service to demanding Bostonians.

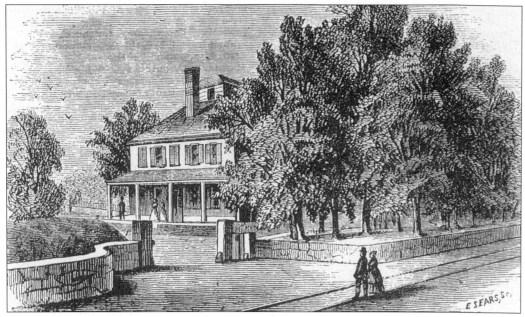

The Wilder House was an extensive estate at the present corner of Washington Street and Columbia Road. Built in the late 18th century by Gov. Increase Sumner and known as Hawthorne Grove, it was developed as a horticultural marvel by Marshall Pinckney Wilder, who served as third president of the Massachusetts Horticultural Society. At one time, Wilder reputedly grew 900 varieties of pears in addition to operating the Dorchester Nursery and a mail-order garden supply house, which provided plants such as the hybrid Dorchester Blackberry and the President Wilder Strawberry.

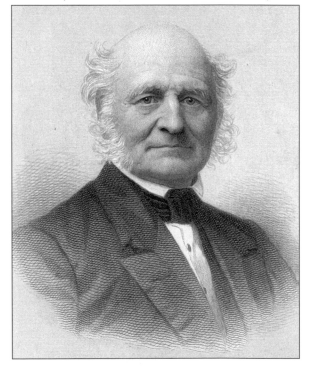

Marshall Pinckney Wilder (1798–1886) was a wealthy Boston merchant whose interest in horticulture led him to serve as president of the Massachusetts Horticultural Society from 1840 to 1848 and also of the American Pomological Society. A specialist in the cultivation of camellias, he hybridized the *Camellias Wileri*, the Mrs. Abby Wilder, the Mrs. Julia Wilder, and the Jennie Wilder. In 1839, Wilder's entire collection of greenhouse and garden plants went to embellish the Boston Public Garden, laid out by his gardner John Fottler Sr.

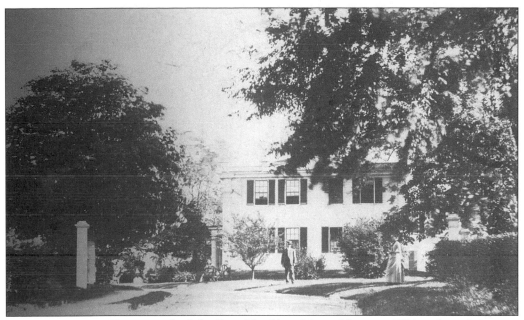

The Harris-Capen House was built by Rev. Thaddeus Mason Harris in 1793 and was known as Mount Ida. The elegant Federal mansion was the site of Harris's hybrid pear, which was appropriately named the *Bon Chretien*, the "Good Christian." The 10-acre estate was purchased by Nahum Capen (1804–1886) in 1840, and was one of the great pre-annexation estates in town. Here, Ned Capen and his sister Mrs. Shelton Barry pose on the driveway to the house (now known as Mount Ida Road). In 1916, the estate was subdivided and laid out with the following streets: Mount Ida Road, Potosi, Fox, Marie, Juliette, Draper, and Hamilton Streets.

Edward Nahum Capen (1835–1916) was the only son of Nahum Capen, the postmaster of Boston from 1857 to 1861, to whom the invention of the corner mailbox is credited. Ned Capen, a Boston representative of the Standard Oil Company, lived on the family estate until his death, after which portions of the house, scenic wallpaper, and garden ornaments were removed to a niece's summerhouse in Camden, Maine, and the property was developed for multiple-family houses. A large portion of the estate was purchased by the City of Boston and laid out by G. Henri Desmond as Ronan Park, which was named for Rev. Peter Ronan (1842–1917), the ever popular rector of St. Peter's Church.

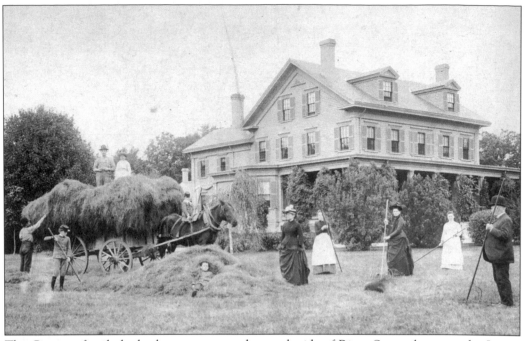

The Conness family had a large estate on the north side of River Street, between the Lower Mills and Mattapan. The Honorable John Conness (1822–1909), a retired senator from California, is on the far right; family and friends assist in haying the field in front of the family home. Notice the horse-drawn hayrick on the left with the children standing on its top. Today, this is the site of the Mattapan Public Health Commission; the Women's Educational and Industrial Union uses the Conness House for Horizons, a safe house for battered women and their children.

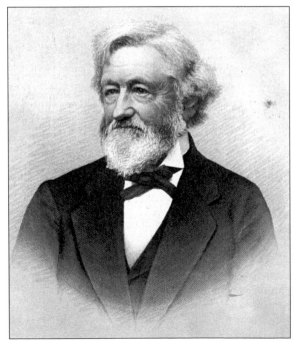

Samuel Downer Jr. (1807–1880) owned the Downer Oil Company in Boston and was the proprietor of Downer's Landing, an alcohol-free amusement park at Crow Point in Hingham. An avid horticulturist, he hybridized the Downer Late Cherry. He was called "a man of practical piety, of sterling sense, of fine business ability, and a benefactor to the community." Downer Avenue on Jones Hill, laid out in 1871, was originally the carriage drive to his estate.

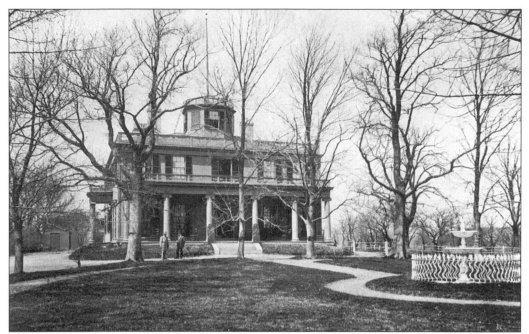

Belvidere Hall was an elegant mansion that once stood on Blue Hill Avenue, near Franklin Park. It was built c.1840 by Frederick Gleason, publisher of *Gleason's Pictorial Drawing Room Companion*. Landscaped with serpentine drives, fountains, and stands of mature trees, the estate was testimony to Gleason's success as a newspaper publisher.

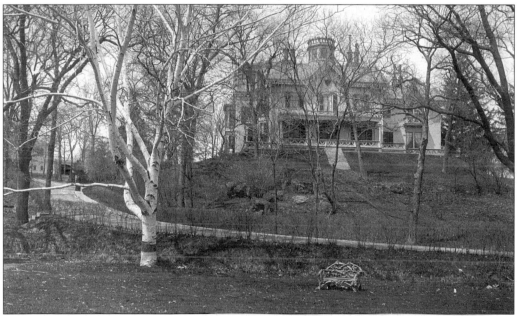

Oakland was designed by Luther Briggs Jr. and built in the late 1840s for Robert Chamblett Hooper (1805–1869), a wealthy Boston merchant and ship broker. The estate was subdivided in the late 19th century, with Sargeant, Hartford, Lingard, Robin Hood, Chamblett, Hooper, and Half Moon Streets laid out for new, well-designed Victorian houses. (Courtesy of the late Gertrude Hooper.)

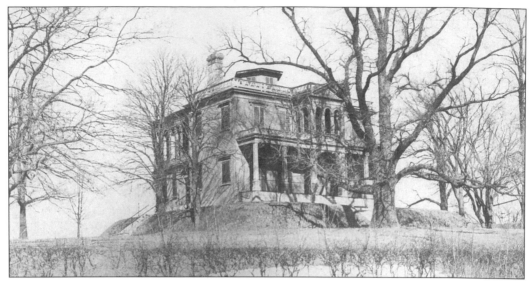

Located at the corner of East Cottage and Pond Streets, the Andrews House was a magnificent mansion with stables, greenhouses, and a bowling saloon. William T. Andrews was a well-known horticulturist. His estate included more than 50 acres east of Dorchester Avenue between present-day Columbia Road and Belfort Street. His neighbor across the street, Zebedee Cook, second president of the Massachusetts Horticultural Society, hybridized the Nice grape.

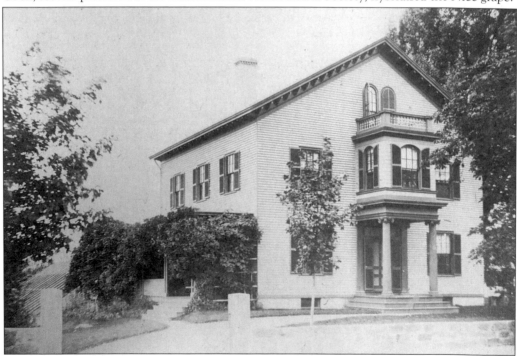

The Lewis House is a substantial Italianate house at 597 Adams Street, between Wrentham and Templeton Streets. Edwin J. Lewis Jr. (1859–1937) was a noted shingle-style architect who designed more than 40 Unitarian churches in the United States and Canada, among them Christ Church, Dorchester. Also a prolific residential architect, Lewis designed numerous houses in town between 1887 and his death.

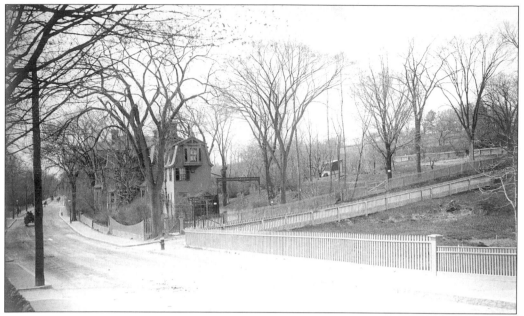

The Fox-May House was built in 1859 on the corner of Adams and Fox Streets. Built by Rev. John Fox and designed by Luther Briggs Jr. (1822–1905), the Italianate house still stands at 69 Adams Street. When the May family owned the house, they called it Underhill, as it was literally under Mount Ida. In the early part of the 20th century, most of the surrounding land was developed with three-deckers built in the period from 1910 to 1920. (Courtesy of John Fox and the late Walter S. Fox.)

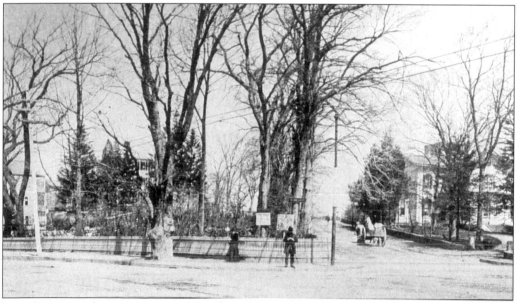

Four Corners is the intersection of Bowdoin, Harvard, and Washington Streets. Its countrylike setting, seen here in 1893, included the Micajah Pope House on the right. Bowdoin Avenue, with a horse-drawn cart ascending the hill, led to an elegant neighborhood developed in the late-19th century on the site of the farm of Gov. James Bowdoin, for whom the hill was named. (Courtesy of William Dillon.)

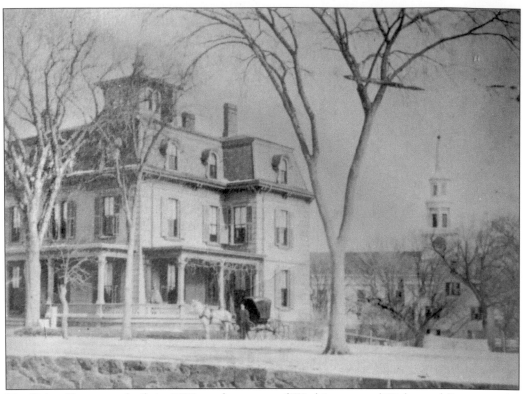

The Baker House was built in 1872 on the corner of Washington and Richmond Streets in the Lower Mills. An elaborate house with a fashionable mansard roof and wide piazzas, it was flanked on the left by the Dorchester Methodist Episcopal (now Wesley) church and on the right by the Third Religious Society. After the house was demolished in 1939, the corner was the site of the Knights of Columbus hall for many years. (Courtesy of the late Marion Woodbridge.)

Edmund J. Baker (1804–1890) was the grandson of Dr. James Baker, the founder of the Baker Chocolate Company, the oldest manufacturer of chocolate in the United States. A surveyor of great repute, Baker produced maps of the area that are works of art. He also served as postmaster of Milton and was a founder and second president of the Dorchester Antiquarian and Historical Society, which was founded in 1843 and was later incorporated into the New England Historic and Genealogical Society. Baker was a large landholder and developed much of the Lower Mills area south of Medway Street.

Dr. Benjamin Cushing was one of Dorchester's leading physicians in the late 19th century. A graduate of Harvard College, he was a founder of St. Margaret's Hospital on Jones Hill in Dorchester. Cushing was also associated with the Boston City Hospital, the State Dipsomaniac Hospital, and the Danvers State Hospital. In 1881, Thacher Avenue, which runs from Columbia Road to Pleasant Street, was renamed Cushing Avenue in his honor.

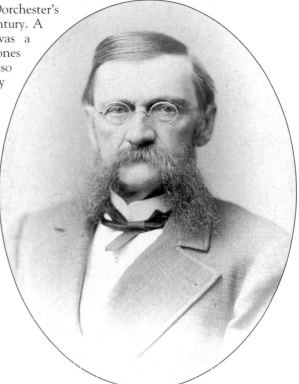

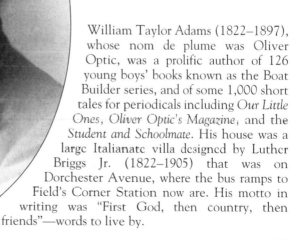

William Taylor Adams (1822–1897), whose nom de plume was Oliver Optic, was a prolific author of 126 young boys' books known as the Boat Builder series, and of some 1,000 short tales for periodicals including *Our Little Ones, Oliver Optic's Magazine,* and the *Student and Schoolmate*. His house was a large Italianate villa designed by Luther Briggs Jr. (1822–1905) that was on Dorchester Avenue, where the bus ramps to Field's Corner Station now are. His motto in writing was "First God, then country, then friends"—words to live by.

Dorchester's separation of church and state occurred in 1816 when the town hall was built at Baker's Corners, known since 1847 as Codman Square. This simple Greek Revival hall served as a place where debates on town issues took place. It was also where the pro-annexationists carried the vote that annexed Dorchester to the city of Boston on January 4, 1870. The town hall remained a community center until 1904, when it was replaced by the former Codman Square Branch of the Boston Public Library (now the Codman Square Health Center). In the center is Baker's Grocery Store (now the site of the Lithgow Building) and on the far left, the Joseph Clapp House on Centre Street.

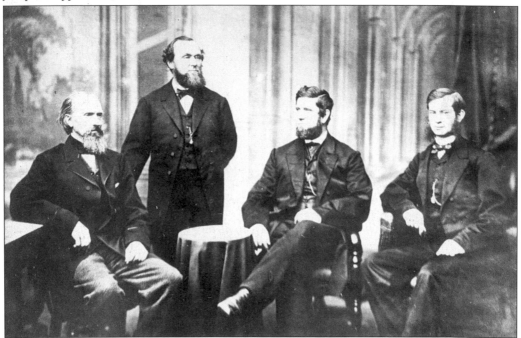

The last selectmen of the Town of Dorchester were William Pope; James Humphreys Upham, chairman; William E. Swan; and Thomas French Temple, town clerk and treasurer. Their support of Dorchester's accepting annexation to the city of Boston carried the vote. From a town with a population of 12,000 in 1869, Dorchester approached 100,000 c. 1900 and is reputed to have reached a quarter of a million by the Depression.

Two

AFTER THE ANNEXATION

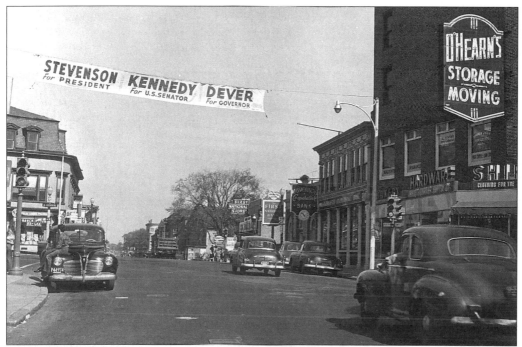

Following Dorchester's annexation to the city of Boston in 1870, Dorchester Avenue became a major road connecting South Boston to the Lower Mills. Here, Field's Corner looks north at the intersection of Adams Street in the late 1950s. On the left is the Robinson Block; on the right the First National Store, the First National Bank (now BankBoston,) the Massachusetts Co-Operative Bank, and O'Hearns Storage and Moving Company can be seen. A canvas banner spans Dorchester Avenue with the names of Democrats running for president of the United States, U.S. senator, and governor of Massachusetts. A thriving retail district, Field's Corner remains virtually the same today—50 years after this photograph was taken. (Courtesy of the Massachusetts Co-Operative Bank.)

The Pierce House was designed by John A. Fox and was built in 1884 at the corner of Columbia Road and Bodwell Street, just west of Upham's Corner. Samuel Bowen Pierce (1806–1895) was a wealthy Boston merchant; after his death, his son built the S.B. Pierce Building at Upham's Corner on the site of his father's previous house. The Pierce Estates condominiums on Columbia Road perpetuate the family's connection to the neighborhood, although this grand house was destroyed by fire during World War II. (Courtesy of the late Elizabeth B. Hough.)

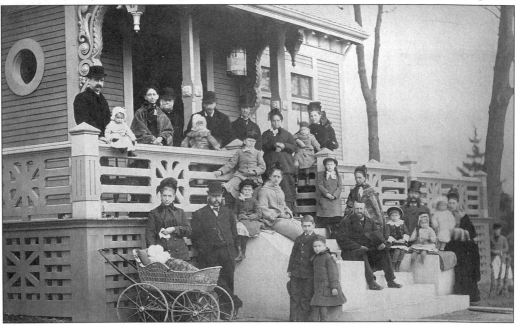

Members of the Pierce family pose on the front piazza of their house during the 50th wedding anniversary celebration of Samuel Bowen and Hannah Rea Pierce, seen in the center. Their son J. Homer Pierce (1840–1933) is on the far left with a derby; a wealthy developer, he had John A. Fox design his own house at 14 Bellevue Street, just across the street. (Courtesy of the late Elizabeth B. Hough.)

30

Micah Dyer (1829–1917) was an attorney and trustee of estates in which "the integrity of his administration gained him high esteem." A member of the House of Representatives from 1855 to 1856, he was admitted to practice in the U.S. Supreme Court in 1861. It was said of him that he did "much benevolent work in a quiet way and unostentatiously . . . expended thousands of dollars in rendering life easier [for] the poor, the sick, and the unfortunate."

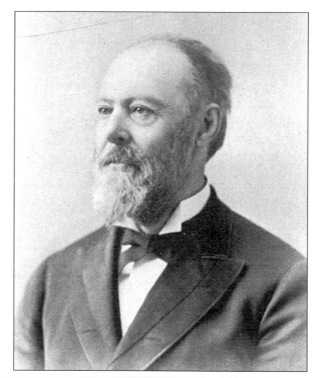

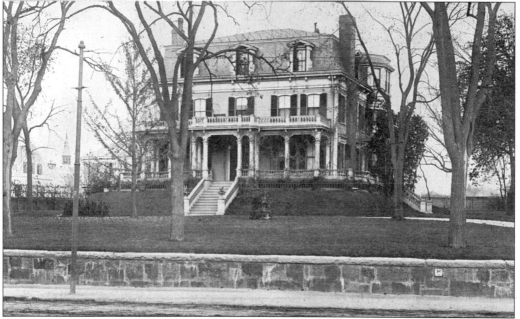

The Clapp-Dyer House was a Federal-style house built by James Clapp in 1810 at the corner of Columbia Road and Hancock Street. Purchased in 1867 by Micah Dyer, an attorney who moved from Boston's South End, it was remodeled as an Italianate house with a front piazza overlooking a wide lawn. The house survived until 1917, when it was razed to make way for the Strand Theater, which was designed by Funk and Wilcox. The theater opened to the public on Armistice Day in 1918.

31

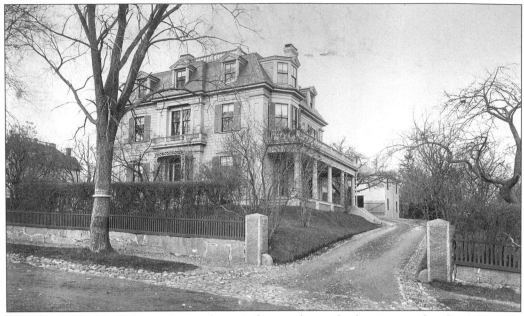

The Stone-Blackwell House was a large Italianate house built prior to the Civil War on Boutwell Street on Pope's Hill. Lucy Stone and her husband Henry Blackwell were well-known reformers. She was the first Massachusetts woman to graduate from college (Oberlin, 1838); the first woman to maintain her maiden name after marriage; the first female editor (the *Womens Journal*); and, upon her death in 1893, the first person to be cremated in the United States. The estate remained in the family until after 1910, when the couple's daughter allowed the property to be used for a program that gave inner-city children a chance to experience a day in the country. The house was destroyed by fire in 1966.

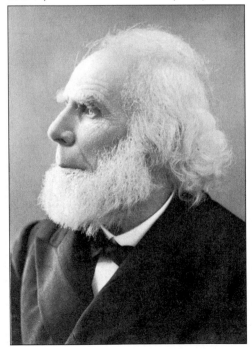

Henry Browne Blackwell (1825–1909) was a reformer and abolitionist who supported and encouraged the ideals espoused by his wife. Following Lucy Stone's death in 1893, Blackwell began developing land to the south of Pope's Hill, laying out Blackwell and Bowman Streets for residential development.

John P. Spaulding (1833–1896) was often referred to as the Sugar King of Boston, for his great wealth derived from the Revere Sugar Refinery. His family's palatial estate was on the crest of Pope's Hill in Dorchester, overlooking Dorchester Bay to the east and the Blue Hills to the west. It was later developed with Daly, Ainsley, Rosemont, Spaulding, Rosselerin, Matignon, Manor, and Auriga Streets, and Garner Road laid out on the former estate.

The Spaulding House was an imposing cupolaed mansion designed by Luther Briggs Jr. (1822–1905) and built on the crest of Pope's Hill (now Daly Street). It was built for Mahlon D. Spaulding, who dubbed the hill Spaulding Hill in the 1860s. The 10-acre estate comprised much of the land on the top of the hill; after it was sold to the Archdiocese of Boston, the mansion was used as the Daly Industrial School until it was demolished in the 1950s and houses were built on the site.

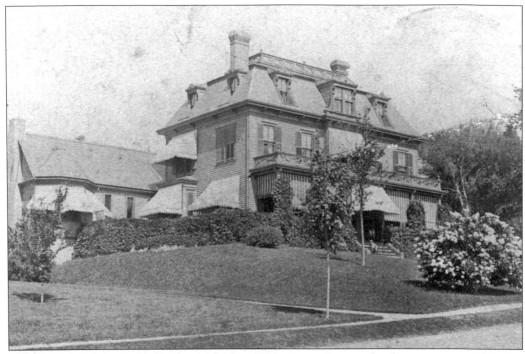

The Herbert S. Carruth House was built on Beaumont Street, the former carriage drive to Beachmont, his father's estate, which was on the crest of the hill between Wilcox and Bateswell Roads. Designed by Luther Briggs Jr., the house still stands at the corner of Fossdale Road. (Courtesy of Letitia Carruth Stone.)

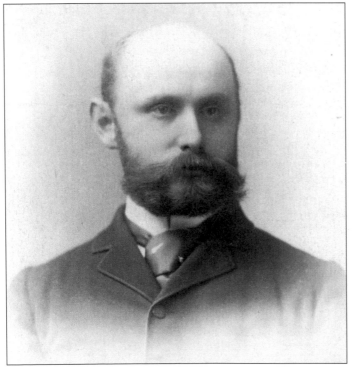

Herbert Shaw Carruth (18565–1917), the son of Nathan Carruth, developed much of his family's 18-acre estate in Ashmont in the late 19th century. He laid out Beaumont Street, originally the carriage drive to his father's estate, from Carruth to Adams Street and had large, well-designed houses built on the subdivided estate, which attracted wealthy residents. The Ellen Richards School, designed by William H. Besarick, was built on the site of his father's estate in 1913. Today, the site has condominiums. (Courtesy of Letitia Carruth Stone.)

James H. Stark (1847–1919) was a noted historian who authored *The Loyalists of Massachusetts* and *Antique Views of Ye Towne of Boston*. A founder of Dorchester Day and an officer of the Dorchester Historical Society, which he helped to found in 1891, Stark was a well-known promoter of the early history of Dorchester and Boston. His business was the Photo Electro Company, Boston, which printed numerous historical books with linecut drawings as illustrations.

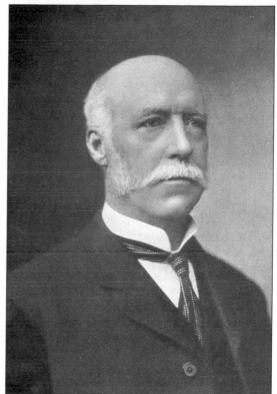

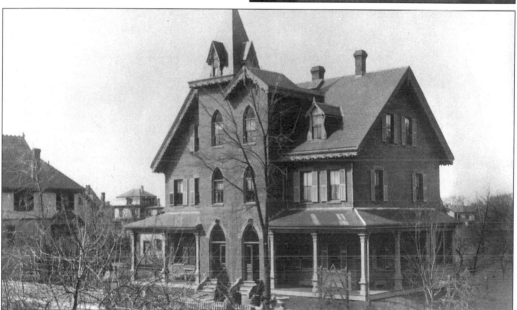

The Stark House was a duplex built by John Stark (1823–1885) for his two sons Frederick and James H. Stark at 252–254 Savin Hill Avenue. A fantastic Gothic Revival red brick house, it has an asymmetrical center tower with lancet-shaped doors and windows. The house on the far left (244 Savin Hill Avenue) was that of the father, John Stark, a native of Shepton Mallet, England. (Courtesy of Marta Carney.)

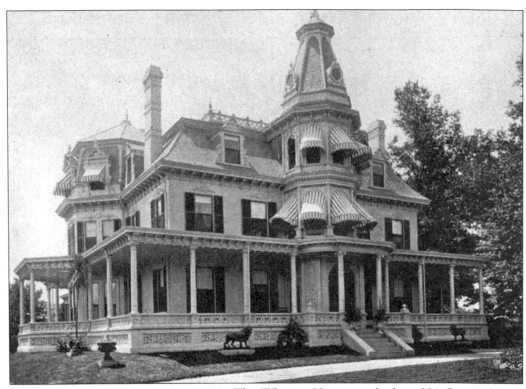

The Whitten House was built at 321 Centre Street, just east of Dorchester Avenue. An Italianate house with a center tower and an octagonal cupola, a wraparound piazza, and cast-iron garden ornaments, this estate was as impressive as it was comfortable. The Whitten House boasted a billiard room, an indoor bowling saloon, and numerous reception rooms. In its later years, the house became Dr. Charles Douglas's sanitarium. It was demolished in the 1940s to make way for St. Joseph's Manor. (Courtesy of Roger Pierce.)

Charles Varney Whitten (1829–1897) was a successful Boston merchant in the firm of Whitten, Burdett, & Young; he also served as president of the Boston Board of Aldermen (Boston City Council) in the late 19th century. He is reputed to have grown "some of the rarest and most beautiful varieties" of roses on his spacious grounds in Dorchester. Whitten Street, originally a drive to the carriage house, was named in his honor.

Laban Pratt (1829–1923) was a prominent manufacturer and lumber merchant at Port Norfolk who lived in a house on Pope's Hill overlooking Dorchester Bay. His generosity upon his death ensured the continuation of the efforts of the South Shore Hospital, which received just over a quarter of a million dollars for its efforts, with the construction of the Laban Pratt Memorial Wing.

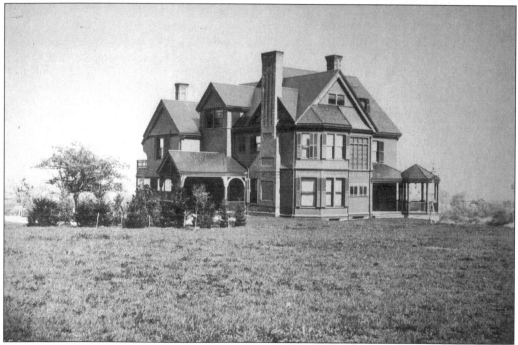

Designed by John A. Fox, the Laban Pratt House was built on Pope's Hill in 1882. An eclectic design with shingles of different patterns, projecting bays, and an octagonal side porch overlooking Dorchester Bay, its driveway was later laid out as Laban Pratt Road, which runs from Boutwell Street to Westglow Street. (Courtesy of John Fox and the late Walter S. Fox.)

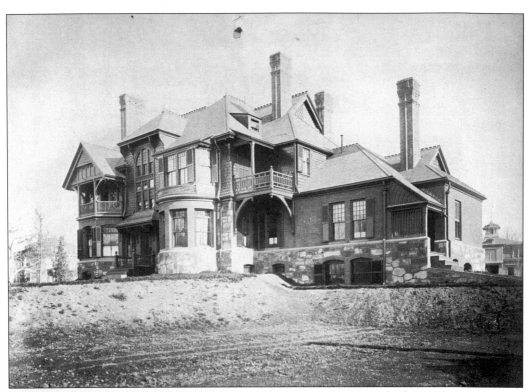

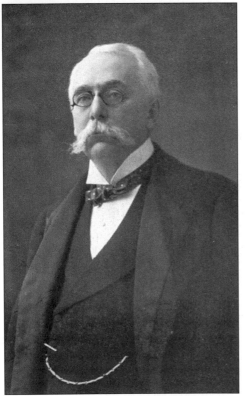

The Torrey House was built in 1880 on the corner of Washington Street and Melville Avenue. Designed by the noted architectural firm of Cabot and Chandler, this was probably Dorchester's finest late-19th century mansion. With red brick, stonework, and a profusion of shingle-style details, this house was an impressive Victorian mansion that survived until the late 1930s. After its demolition, the brick was reused for the small houses built in the early 1940s on Melville Lane, which was originally the carriage drive. The carriage house on the right was a retirement home known as Resthaven, which was demolished in 1927 for the Dorchester District Court.

Elbridge Torrey (1837–1914) was the president of Torrey, Bright, & Capen, importers and dealers in fine carpets, located on Washington Street in Boston. Torrey served as a deacon of the Second Church in Codman Square and was active in the American Board of Commissioners of Foreign Missions, visiting the missions in Ceylon and Turkey and supporting them financially. Torrey Street, just south of Codman Square, was named in his honor.

The Honorable Patrick A. Collins (1844–1905) was born in Ireland and immigrated to Boston with his mother four years later. An 1871 graduate of the Harvard Law School, he was elected state representative in 1868 and 1869, and state senator in 1870 and 1871. He was a judge advocate under Governor Gaston and was later president of the Irish Land League and received ceremonial freedom of Dublin and Cork. In 1893, this fiercely Catholic politician was appointed consul general at London, serving for four years. Upon his return to Boston, he was elected mayor in 1901 and served until the time of his death.

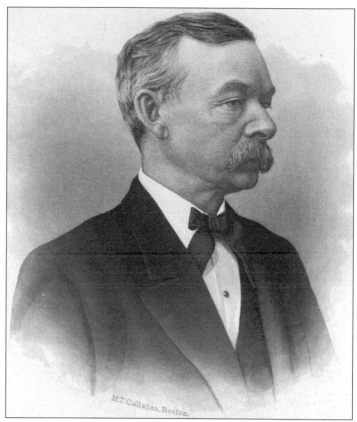

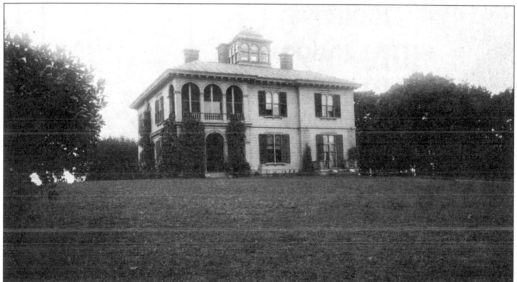

The Collins House was at the end of Percival Street on Meeting House Hill. Built in 1870, overlooking Dorchester Bay, the house was adjacent to the Harris-Capen House, which was known as Mount Ida. Both structures were demolished shortly before World War I. The land was used by the City of Boston to create Ronan Park, named in memory of Fr. Peter Ronan (1842–1917), the first rector of St. Peter's Church on Meeting House Hill in Dorchester.

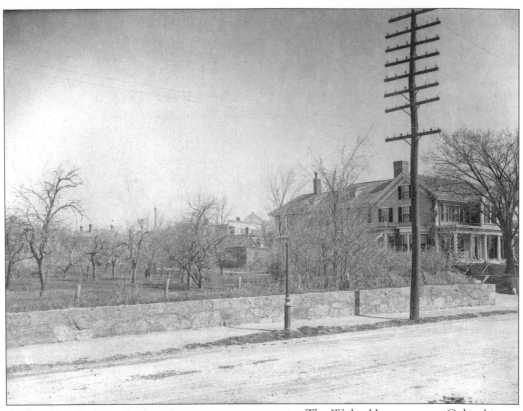

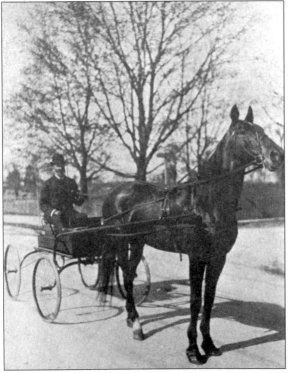

The Wales House was on Columbia Road between Oldfields and Stanwood Streets. S. Walter Wales was in the hack, livery, and stable business at Grove Hall and was proprietor of the Boulevard Stables at 460 Blue Hill Avenue. In addition to three greenhouses, Wales kept a paddock for his race horses Rondo, Clara, Chrome, and Kitty behind his house.

S. Walter Wales poses in his carriage with Rondo, his prized bay pacing gelding. A founder of the Dorchester Gentlemen's Driving Club, Wales served as its president in 1901 and 1902. The premise of the driving club was of "uniting the lovers of the noble horse . . . in matinee and speedway racing," which took place on a track encircling Franklin Field, laid out in 1904.

John A. Fox (1835–1920) was a prolific stick-style architect who designed more than 70 houses in Dorchester after the annexation. In collaboration with Holbrook & Fox, a land development company headed by S. Pinckney Holbrook and Thomas B. Fox, John A. Fox often designed houses for the newly laid out lands of Dorchester real estate speculators. Fox's own house at 25 Trull Street was built amongst at least 15 other impressive houses that he designed and built on Trull, Rill, Ware, and Bellevue Streets. (Courtesy of John Fox and the late Walter S. Fox.)

Looking from Payson Avenue towards Jones Hill in the 1880s, Hancock Street is being rolled following a snowstorm. The houses in the foreground—numbers, from left to right, 36, 42, and 50 Hancock Street—were designed as speculative houses by John A. Fox for S. Parkman Dexter, whose estate was just south of these new houses. At the upper right is the Charles A. Green Estate, built in 1870, which later became St. Mary's Infant Asylum and then St. Margaret's Hospital, the leading maternity hospital in 20th-century Boston. (Courtesy of the Freeman Family.)

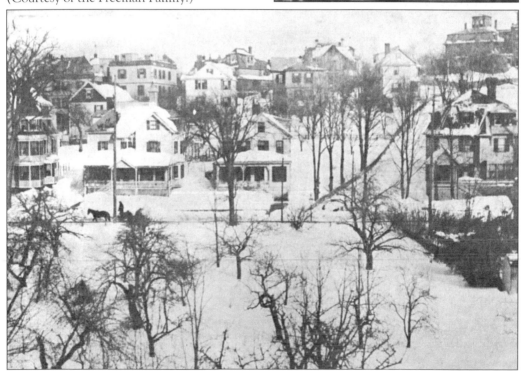

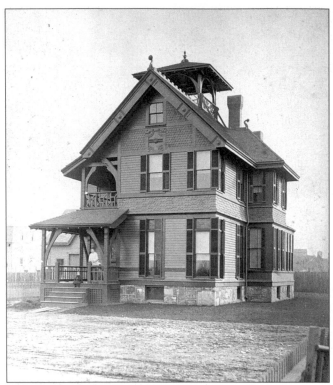

John A. Fox designed this stick-style residence at 44 Monadnock Street for George F. Milliken. A well-designed house with a profusion of stick-style details, it was built on a street laid out in 1881 for upscale residences near the Bird Street railroad station. The house was used during the mid-20th century as the rectory of St. Kevin's Church in Upham's Corner.

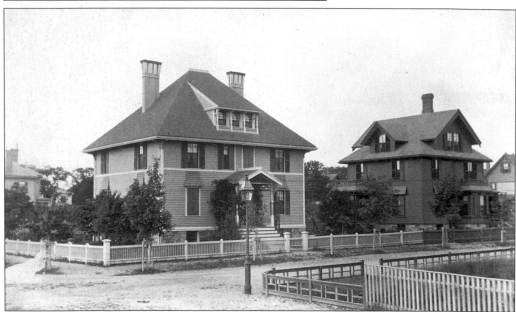

The Dexter Cutter House, on the left, and the Frank Cutter House were designed by John A. Fox and built in 1887 at 15 and 11 Blanche Street in Harrison Square, an area now referred to as Clam Point. These houses were typical of Fox's design, with large sloping roofs punctuated by dormers and massive chimneys. Darius Cutter was the owner of the D.J. Cutter Coal & Wood Company on Commercial Point, a family business that continues to provide heating service to the community. (Courtesy of the Cutter Family.)

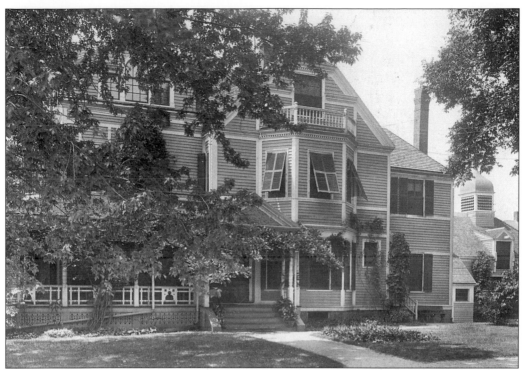

The Hartford House was built at the corner of Harley and Roslin Streets. Designed by John A. Fox, it was later remodeled by Edwin J. Lewis Jr. Both men were leading architects of Dorchester. Here, the sun blinds are mounted on the windows; vines cover the piazza, making for cool shade during the summer. Notice the cupolaed stable on the right, something that was replaced not long afterward by automobile houses. (Courtesy of the Hartford Family.)

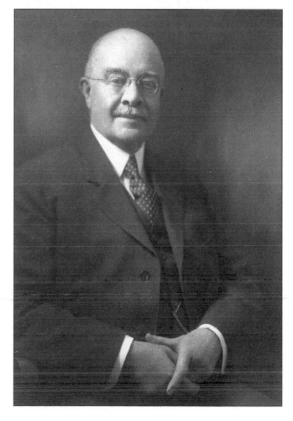

Edwin J. Lewis Jr. (1859–1937) was one of the finest shingle–style architects of the late 1800s and early 1900s. A graduate of Massachusetts Institute of Technology, he later studied with Peabody and Stearns before beginning a 50 year private practice that continued until his death in 1937. He designed the Peabody at Peabody Square, Christ Church at Dix Street, and numerous private residences in Dorchester. It is said that during his career, he designed more than 40 Unitarian churches in the United States and Canada.

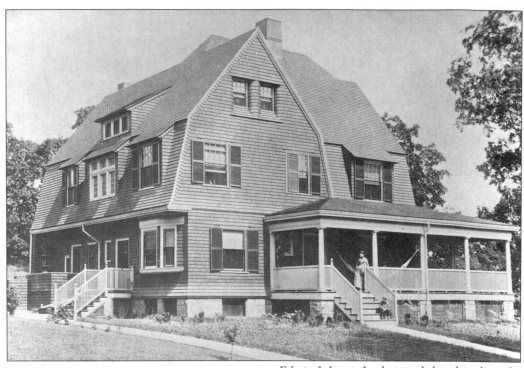

Edwin J. Lewis Jr. designed this shingle-style house at the corner of Carruth Street and Elmer Road in Ashmont for the Goodale family. Lewis's interpretation of architecture drew heavily on 17th-century prototypes, with brown stained shingles, bracketed overhangs, and leaded glass casement windows. Lewis had "a distinctive style that is quickly recognizable," according to the noted architect Frank Choteau Brown. On the interior, Lewis often incorporated sitting areas, inglenooks, and seats on either side of a fireplace, all of which became his trademark style.

Charles H. Greenwood (1832–1913) had an extensive dairy farm on Harvard Street between Waterlow and Gleason Streets. In the 1870s, he began the subdivision of his land for new streets and speculative houses, which were conveniently located near the Harvard Street depot of the Midlands Division of the Boston, Hartford, & Erie Railroad. His entailed generosity to his church ensured its being renamed in his honor, and the Greenwood Memorial Church near Four Corners is testimony to his benevolence and desire for immortality.

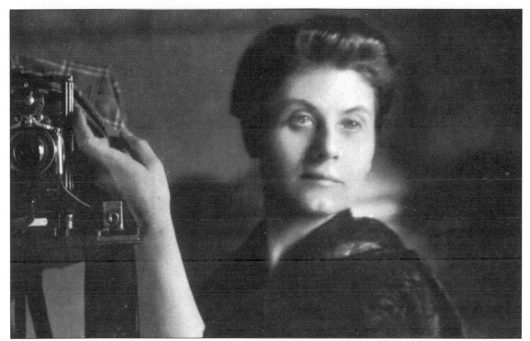

Chansonetta Stanley Emmons (1858–1937) was a well-known photographer who poignantly captured the fast disappearing world of the 19th century in an artistic photographic form. The sister of the famous Stanley brothers, manufacturers of the Stanley Steamer, an early horseless carriage, she was a sharp discerner of realism in photography, an art in which she excelled.

The Emmons House, a large house typical of the new streetcar residents, was built at 22 Harley Street on Ashmont Hill. A large, turreted Queen Anne house, it was set on a slight knoll with a small barn in the rear for the family's dairy cow. The young girl in front of the house is Dorothy Emmons, daughter of James and Chansonetta Emmons, a frequent model for her mother and, later, an accomplished etcher.

The Honorable John F. Fitzgerald (1863–1950) served as mayor of Boston in 1906 and 1907 and again from 1910 to 1913. He was a state senator in 1893 and a representative from 1895 to 1901. A personable man, "Honey Fitz" is said to have been "one of the most popular of the men to have held the office of mayor of Boston." After his retirement, he resided at the Hotel Bellevue on Boston's Beacon Hill and lived to see his grandson John Fitzgerald Kennedy continue the family's participation in political life.

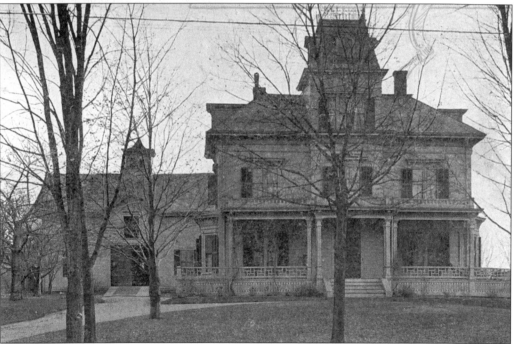

The Fitzgerald House was a large dwelling built c. 1870 at the corner of Welles Avenue and Harley Street. An Italianate house with a wide piazza and center turreted tower, it studiously dominated the crest of Welles Avenue and was always conspicuously decorated with masses of flowers and flags and bunting when the mayor was in residence. Today, five small houses have been built on the site of the house.

Designed by Samuel J. Brown, the Fottler House was built in 1900 on the corner of Washington and Algonquin Streets, opposite Mother's Rest, for John Fottler Jr., who was in the produce business at Quincy Market. An impressive house with a bow front porch and monumental Ionic columns, it makes an impressive statement on Washington Street. On the left is the Tucker House, which was in the curve between Bradlee and Algonquin Streets, which were laid out as Carlton Hill, a development by Joseph P.B. Carlton. The Bullock Funeral Home maintained a prominent undertaking business in the old Fottler House for almost four decades.

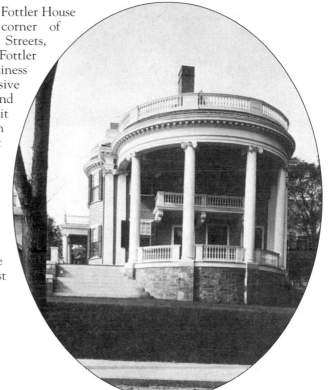

John Fottler Sr. (1815–1890) was a produce grower for the Boston markets, with a farm near Walk Hill Street in Mattapan. A well-known gardener and "in all respects a self-made man," he was also a developer credited with the widening of Blue Hill Avenue in the 1880s. Fottler Road was cut through his farm off Walk Hill Street and was named in his honor.

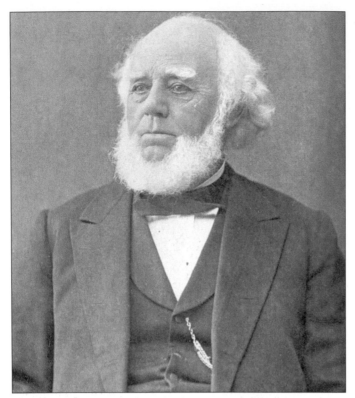

Ralph Butler (1813–1915) was a Boston wholesale flour merchant who developed his estate in the Lower Mills in the 1870s, laying out Butler Street through his property. An adventurer in his youth, Butler went to California during the gold rush, where he built and operated the steamboat *Orient* on the Sacramento River; he invested his income in building a business block in Sacramento before returning to Boston, where he became a successful merchant and, later, a land developer in Dorchester.

Capt. John Percival (1779–1862), a captain of the USS *Constitution*, lived at the corner of Bowdoin and Percival Streets on Meeting House Hill in retirement. He was known as "Mad Jack" Percival for his daring seamanship. His cottage was moved to Percival Street after the land was purchased by the Archdiocese of Boston for the future site of St. Peter's Church. Built in 1872, from the pudding stone quarried from the site, St. Peter's Church was designed by the noted architect Patrick J. Keely.

Richard Clapp Humphreys (1836–1912) was a partner in the J.H. Upham & Company in Upham's Corner before becoming a junior partner of Holbrook & Fox, prominent real estate dealers in Boston. In later life he became a trustee of estates, and it is said that "no small part of his time was given to philanthropic and educational work and other forms of public service." He served as a member of the Boston School Committee, the Board of Overseers of the Poor, the Dorchester Board of Associated Charities, and the Dorchester Relief Society.

On Ashmont Hill, Walter E. Newbert stops Alice B, his chestnut trotting mare, in front of 17 Roslin Street, with number 19 on the left. The two houses were designed by local architect Edwin J. Lewis Jr. and were built on the former Welles Estate, which was developed in the late 19th century as a quintessential streetcar neighborhood. Newbert lived at 15 Roslin Street and served as a president of the Dorchester Gentlemen's Driving Club.

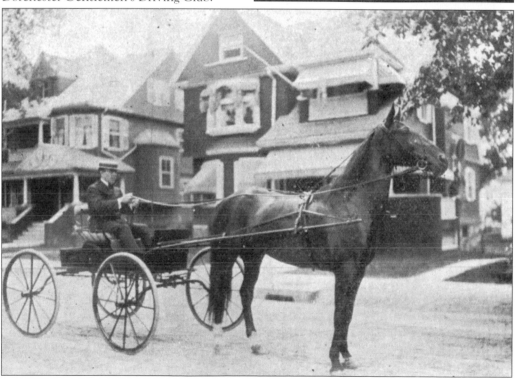

Frank L. Young (1852–1937) was the head of the Frank L. Young Oil Company, "believed to be the largest oil manufacturing house in the United States" *c.* 1900. It is said that "he exemplifies as perfectly as any businessman in Boston that type of strong, self-reliant character which surmounts all obstacles, and, with no aid from external sources ... achieves a most remarkable and thoroughly deserved success."

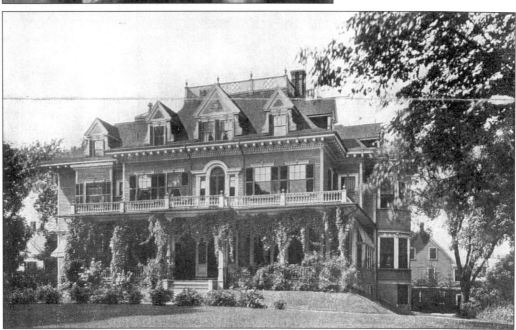

The Young House was built at 294 Ashmont Street on the crest of Ashmont Hill, between what is now Adanac Terrace and the Calvary Baptist Church. Designed by Edwin J. Lewis Jr, this house was undoubtedly Lewis's finest and most bombastic residential design, with exuberant Colonial Revival details. Unfortunately, the house was demolished in 1938. (Courtesy of Stephen Wentworth Giffssord.)

Harrison H. Atwood (1863–1954) was the city architect for Boston from 1899 to 1901. A prolific architect, he studied with Samuel J.F. Thayer and George Clough. Atwood designed numerous Boston schools, among them the Emily Fifield and the Henry L. Pierce Schools in Dorchester. He designed his own home at 61 Alban Street on Ashmont Hill and numerous other private residences in town.

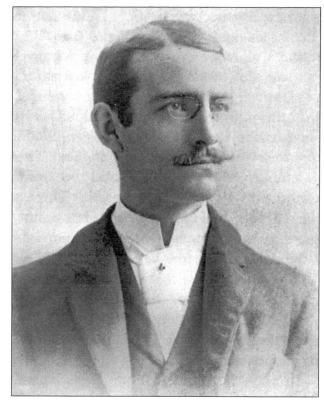

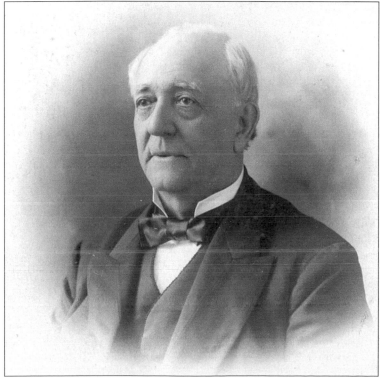

Charles Austin Wood (1818–1898) was an architect who lived on Woodworth Street in Port Norfolk, where he designed the impressive Second French Empire headquarters of the Dorchester Mutual Fire Insurance Company, which was founded in 1855. He also designed his Egyptian Revival granite tomb in the Old North Burying Ground at Upham's Corner.

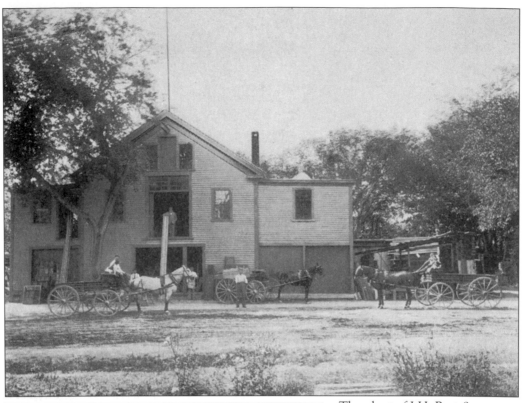

The plant of J.H. Burt & Company was on Blue Hill Avenue in Mattapan. Founded in 1850, the Burt Brothers milled the lumber that was used in the large-scale development of Dorchester and surrounding towns in the boom years following the Civil War.

John H. Burt (1827–1907), in partnership with his brother George L. Burt, founded a building and contracting concern that was one of the leading purveyors of lumber for Boston. Burt built speculative houses on Oakland Street with surplus lumber. He lived in Milton, where he served as a member of the board of selectmen for many years. His brother lived in Mattapan and served as a state representative and senator from 1884 to 1885.

Noted Dorchester builder Frederick Leeds Pierce (1829–1910) worked as a joiner and mason and constructed many of the houses built in town between 1860 and 1885. A descendant of the Pierces who settled Dorchester in 1630 (the Pierce House, c. 1650, still stands on Oakton Avenue), he continued bettering his community in his own way by "giving employment to as many as from 20 to 75 hands" in his Dorchester building ventures until his retirement in 1897. He lived at 827 Adams Street, on land owned by his family since 1630.

Albert T. Stearns (1821–1906) was president of the Stearns Lumber Company at Port Norfolk in Dorchester. Arriving at Neponset in 1849, he became "engaged in a large and prosperous trade" and became "widely known among lumbermen." At one time the Stearns Lumberyards covered much of the Port Norfolk waterfront, with wharves projecting into Dorchester Bay. Stearns built speculative houses on Water and Taylor Streets and on Walnut Court in Port Norfolk.

53

Joseph Irving Stewart (1847–1927) was a real estate dealer and builder, whose specialty was the development of investment and residential property. His office was in the Stewart Building on Geneva Avenue, where he "achieved an unqualified success." He erected 61 houses and 3 commercial blocks in Ashmont and 54 houses in Dorchester Centre. He built both the Stewart Building and Bloomfield Hall, next door on Tonawonda Street, later known as the Dorchester Plaza. Stewart was a well-respected man whose "achievements furnish a striking example of what prudence and untiring energy can accomplish."

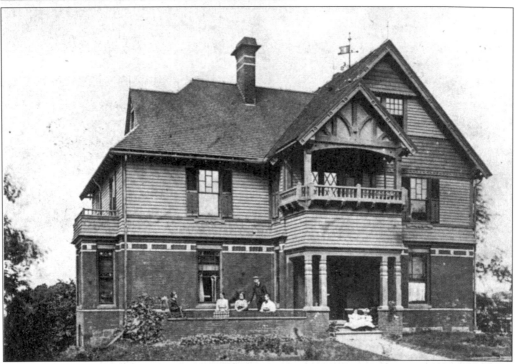

The Bellamy House was built at 17 Bowdoin Avenue in 1881. Designed by William Bellamy (1846–1940) as his own residence, it had a red brick first floor with shingling above. A fanciful mock-Tudor gable, complete with a copper weather vane, projected over a second-floor balcony. Members of the Bellamy family sit on the side porch. The house was demolished in 1940. (Courtesy of Robert Bayard Severy.)

Frederick H. Viaux (1849–1940) was treasurer of the Boston Real Estate Exchange and Auction Board. His house at 8 Wales Street was designed by Edwin J. Lewis Jr. Wales Street runs from Blue Hill Avenue to Harvard Street, opposite Franklin Park.

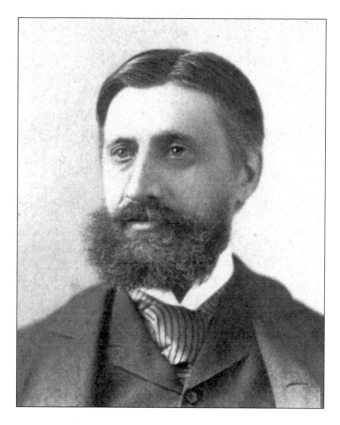

Patrick O'Hearn and his children pose in a carriage outside their home at the corner of Dorchester and Melville Avenues. O'Hearn was the president of the Massachusetts Co-Operative Bank on Dorchester Avenue at Field's Corner. He often raced the family horse Kitty R in the Dorchester Gentlemen's Driving Club races at Franklin Field in Dorchester.

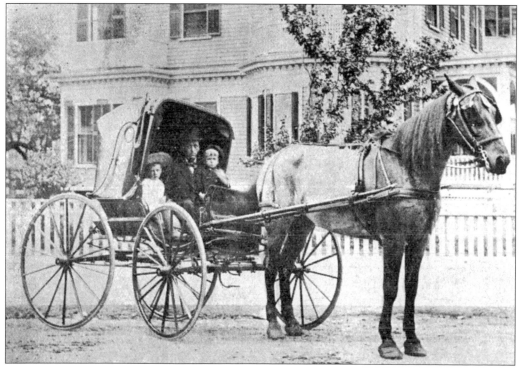

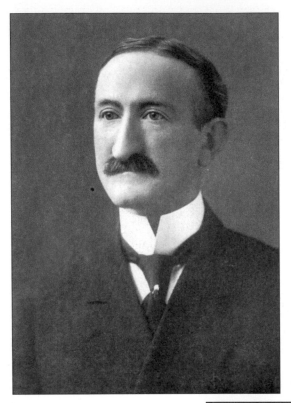

The Honorable George A. Hibbard (1864–1910) served as postmaster of Boston from 1890 to 1907 and as mayor of Boston in 1908 and 1909. A reform mayor, he tried to run an honest and efficient city government but in doing so, he made many enemies. It was thought that his efforts to give the city an honest administration had not been appreciated, and he retired from office a disillusioned man. Hibbard lived at 25 Beaumont Street, Ashmont, in a house designed by John A. Fox.

Anna Clapp Harris Smith (1843–1937) lived at 69 Pleasant Street in the 1804 house built by her grandfather Samuel Clapp. An immensely wealthy woman, she founded the Animal Rescue League of Boston in 1899 to alleviate the plight of the workhorse. With "Kindness uplifts the world," as her motto, she had a great concern for all animals, which she was able to combine with practical means to reduce their unnecessary suffering. Today, the Animal Rescue League continues her vision in Boston.

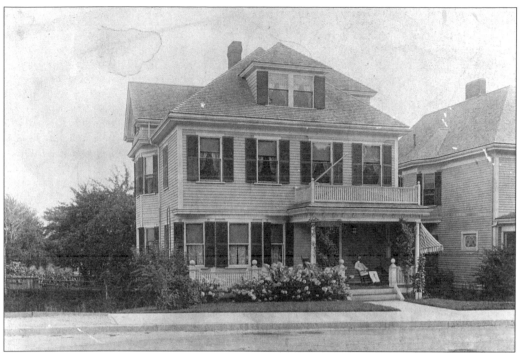

This medium-priced one-family house was typical of those built by developers and speculators on Ashmont Street between Washington Street and Dorchester Avenue. With a small front lawn, often planted with white snowball bushes, and an awning shading the front porch, these houses for the burgeoning middle class sprang up as if by magic in the period from 1890 to 1905.

Isaac Dunn, a building contractor, built his own house at 30 Hecla Street on the east slope of Meeting House Hill. A specialist in houses and factories, he started his business in 1870 and acquired "a very high reputation for square and honorable dealing." His residence was a small one-family house, made unique by the addition of a projecting bay, a sloping roof over the entrance, and a wide front porch.

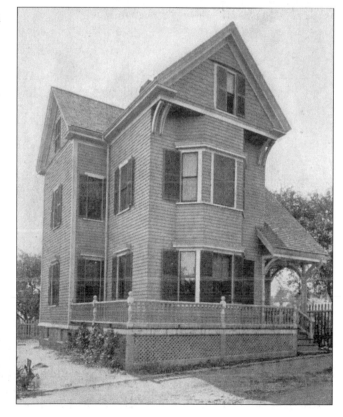

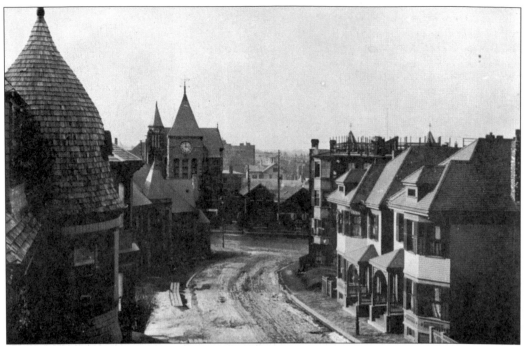

Two-family houses were built at 2, 4, and 6 Cushing Avenue in the 1890s. These small wood-framed houses were within walking distance of Upham's Corner, which offered shopping along Dudley Street and entertainment at the Strand Theatre. The clock tower on the left is that of the Baker Memorial Church at the corner of Columbia Road (now a parking lot for BankBoston). (Courtesy of the Berry Family.)

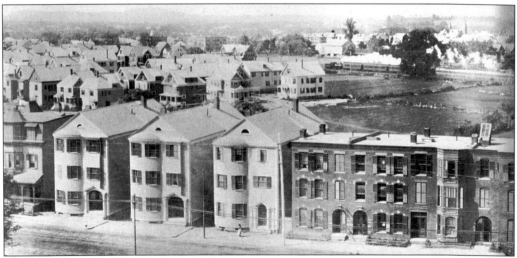

Washington Street, looking west from Mount Bowdoin c. 1900, had detached three-deckers and brick row houses between Vassar and Norwell Streets. A Boston, Hartford, & Erie Railroad (later New York & New England Railroad) train heads west through Red Top Village, the name for this neighborhood of Harvard Avenue, Rupert, Carmen, Vassar, Shafter, Elmont, Radcliffe, and Norwell Streets and Ripley Road. This line had stations at Upham's Corner, Bird Street, Mount Bowdoin, Harvard Street, Dorchester (Norfolk Street), Morton Street, Blue Hill Avenue (Mattapan), and continued on to Readville. (Courtesy of Robert Bayard Severy.)

F.H. McDonald was a well-known building contractor, whose house and woodworking plant were located at 2157 Dorchester Avenue, near the Lower Mills. Established in 1895, the plant provided numerous pieces of prefabricated mill work for houses being built in Dorchester and the surrounding areas in the late 1800s and early 1900s.

In 1893, F.H. McDonald built his own three-decker on Dorchester Avenue in front of his plant and lumberyard. An interestingly eccentric three-decker, it has a flat bay on the left and an octagonal bay on the right, both of which have different roofs and a profusion of exterior details, making the building different from other three-deckers built in Dorchester prior to 1900.

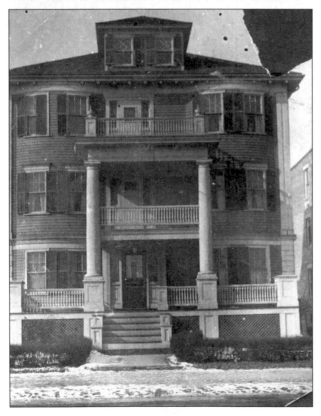

Built at 43 and 41 Pearl Street in 1899, these three-deckers have elegant Colonial Revival details, such as swag-embellished window lintels, a dentilled roof cornice, and roof balustrades. The paired Ionic columns support the front porch roof, which has a balustrade with urn finials—all of which give an elegantly classical impression. The corner of an earlier Greek Revival house at 37 Pearl Street can be seen on the right.

The Weiss Family built this impressive Georgian Revival three-decker at 931 Blue Hill Avenue, opposite Franklin Field. Designed by James T. Ball and built in 1908, this was one of the most impressive three-deckers ever built in Dorchester. With a double bow front, monumental Doric columns, corner quoins supporting paired corner pilasters, and window shutters, this three-decker made an impressive statement for an early Jewish family living in Mattapan.

The Honorable John B. Hynes (1898–1970) served as mayor of Boston from 1950 to 1959 and saw the city undergo tremendous urban renewal changes following World War II. A dedicated city employee for five decades, his personal appeal was legendary. Here, in 1954, he reads to a future Boston voter in a library. Hynes lived on Druid Street near Morton Street in Mattapan, and the Hynes Convention Center on Boylston Street in Boston's Back Bay was named in his memory.

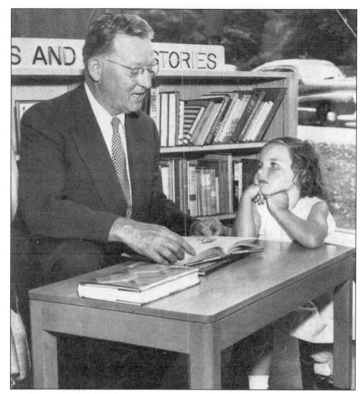

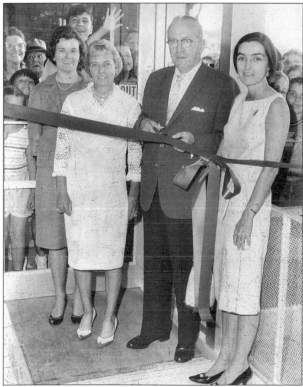

Participating in ribbon-cutting ceremonies for the new Purity Supreme Market at Field's Corner in 1965, from the left to right, are Mrs. James Cifrino; Mrs. John Cifrino; Edward W. O'Hearn, president of the Massachusetts Co-Operative Bank; and Mrs. Paul Cifrino. The Cifrino family established the first supermarket in Upham's Corner and later founded the Purity Supreme Supermarkets. This supermarket was in a mall built on the site of the Park Street Carhouses between Geneva and Dorchester Avenues. (Courtesy of the Massachusetts Co-Operative Bank.)

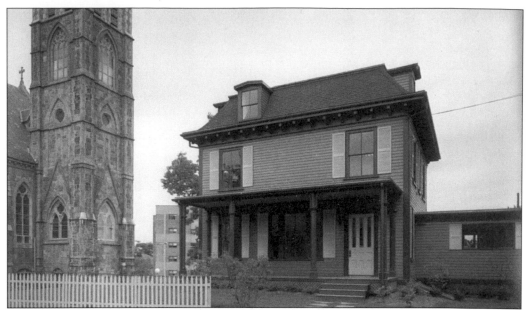

The first building to be restored by the crew of the popular PBS program *This Old House*, offered by Channel 2 in Boston, was the Clapp-Ronan House in Dorchester. A small mansard-roofed house built *c.* 1860 at the corner of Bowdoin and Percival Streets, it was transformed by woodworkers, plumbers, electricians, roofers, and landscapers as a fascinated television audience watched. The house was adjacent to St. Peter's Church, which was designed by Patrick J. Keeley and built in 1872 from pudding stone quarried on the site.

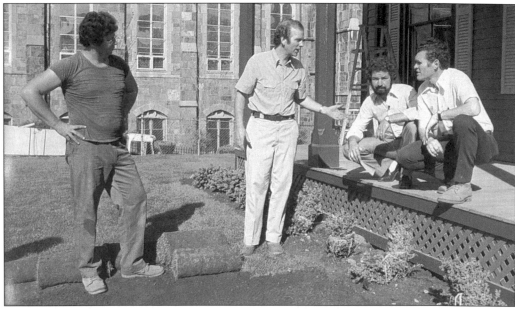

Members of the crew of the popular PBS-produced *This Old House* include, from left to right, Norm Abram; Russ Morash, producer; and Bob Vila, with a beard. The restoration project whet the appetite of the viewer audience and led to numerous other house restoration programs. Rolls of sod are ready to be rolled out for an instant lawn. The pudding stone sidewall of St. Peter's Church, at the corner of Bowdoin and Percival Streets, is visible in the distance.

Three

ALL MODES OF TRANSPORTATION

Dorchester has always had excellent transportation options, being served by the Red Line and a network of bus routes for the last few decades. However, as early as 1820, Dunmore's Stage connected the Lower Mills and Boston at a fare of $1. Stiff competition soon arose, and the once-per-day stage was augmented to once an hour at 37¢ each way. These early modes of transportation were overtaken by horsecar service, beginning in the 1930s with one operated by William Hendry from Meeting House Hill to Boston and in 1856 with another operated by the Dorchester Avenue Railroad Company along the former Dorchester Turnpike. These horsecar lines quickly to spread through the neighborhoods surrounding Boston so that by the time of the annexation in 1870, the town was well served by numerous transportation lines.

However, beginning in 1845, the Old Colony Railroad began the modern aspect of transportation when a line connecting Boston and Plymouth was laid out through town with stations in Dorchester. This line was so successful that three years later, a branch was extended to Mattapan from Harrison Square, further spurring the development of Dorchester Centre. By the time of the annexation of Dorchester to the city of Boston on January 4, 1870, the population was 12,000; just three decades later, it had swelled to 100,000 people. In this case, it was undoubtedly the ease of transportation from the Old Colony Railroad and the Boston, Hartford, & Erie Railroad (later the New York & New England Railroad) that allowed the early development. By 1856, when the Dorchester Avenue Railroad, known as the Metropolitan Street Railway after 1863, laid its line from Boston to the Lower Mills along Dorchester Avenue, the building boom began. That boom continued unabated for the next five decades. Horse-drawn streetcars provided regular but inexpensive service for residents in comparison to the railroads and continued to do so until 1890, when the first electric trolleys were introduced in Dorchester. Within two years, electric trolleys replaced the horse-drawn streetcars, operated more efficiently, and became a major factor in the continuation of the building boom. By 1927, the Rapid Transit Line (now known as the Red Line) was extended from Andrew Square to Field's Corner, and a year later to Ashmont. In 1929, the Rapid Transit opened a high-speed trolley line that transported passengers from Ashmont to Mattapan along the former Shawmut Branch of the Old Colony Railroad.

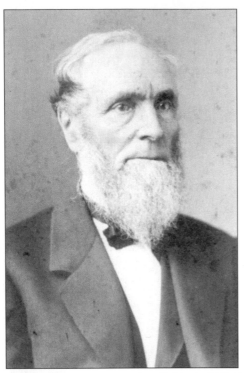

Nathan Carruth (1808–1881) was the founder and the first president of the Old Colony Railroad, which connected Boston and towns south of the city. Incorporated in 1844 and opened on November 10, 1845, the Old Colony Railroad became a major factor for Dorchester's rapid increase in population, with train stations on two Dorchester lines that were known as Crescent Avenue, Savin Hill, Harrison Square, Field's Corner, Pope's Hill, Neponset, Mellvilles, Welles, Ashmont, Lower Mills (Milton), Cedar Grove, and Mattapan. (Courtesy of Letitia Carruth Stone.)

This stock certificate for 18 shares was issued to John Smith in 1847 by the Old Colony Railroad Corporation. The investment in any railroad stock provided a healthy return to investors for much of the 19th century. The Old Colony Railroad opened on November 10, 1845, and was closed on June 30, 1959. The line was reopened on September 27, 1997, and currently serves Boston commuters on the South Shore.

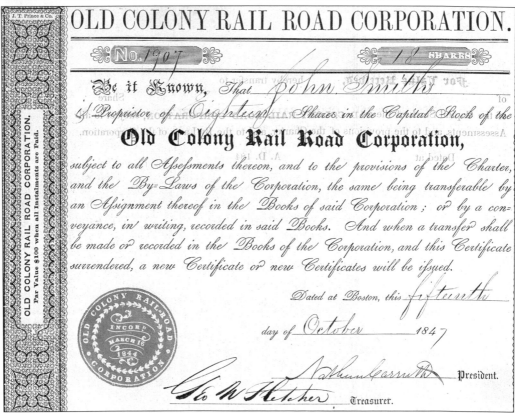

The first depot of Ashmont Station on the Old Colony Railroad stood at the junction of Talbot and Dorchester Avenues, seen on the right; it is now the site of the Englewood Apartments at Peabody Square. Known as the Shawmut Branch, this line opened between Harrison Square and Mattapan with stations at Field's Corner, Mellvilles, Welles Avenue, Ashmont, Lower Mills (Milton), and Cedar Grove. The rapid development attracted large-scale residential and commercial building, including Jacques Grocery Store, built in 1884, on the left and the Ashmont Block, an inexpensive apartment building at the corner of Ashmont Street and Talbot Avenue. (Courtesy of William Dillon.)

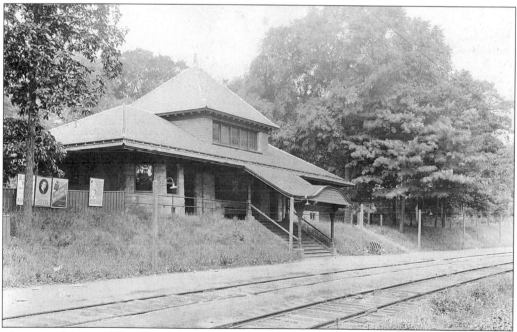

The second depot of Ashmont Station was built on Dorchester Avenue opposite Bailey Street. Photographed in 1923, the stone depot had a waiting room for passengers traveling to town and a staircase that one descended to board the trains. (Courtesy of Frank Cheney.)

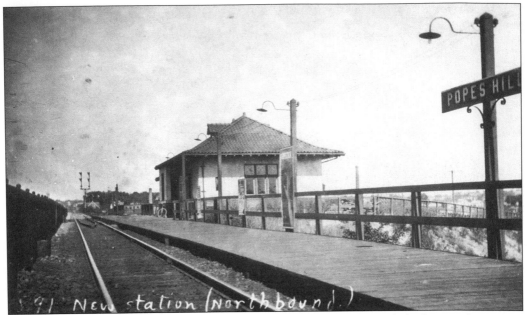

The Pope's Hill station, looking north toward Boston, was an elevated platform with a stucco waiting room and a red tile roof. The depot was at the foot of Pope's Hill Street, the present site of Dunkin Donuts on Morrissey Boulevard. Pope's Hill, which rises to the west of the station, was named for Col. Frederick Pope (1733–1812), whose house was on Neponset Avenue opposite Tilesboro Street. (Courtesy of Stephen Clegg.)

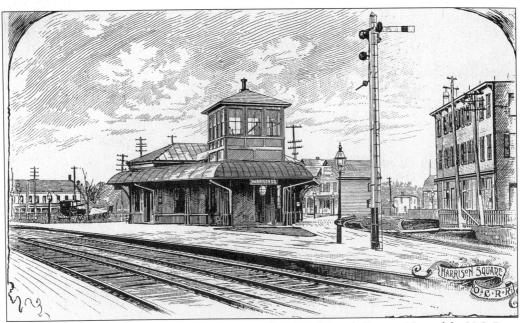

The Harrison Square depot was at the junction of Park and Beach Streets. Named for U.S. Pres. William Henry Harrison (1773–1841), the square was laid out in 1841 by Luther Briggs Jr. as an upscale neighborhood near Dorchester Bay, with access to Boston by the railroad. Today, this charming Victorian neighborhood is referred to as Clam Point. (Courtesy of Robert Mahn.)

66

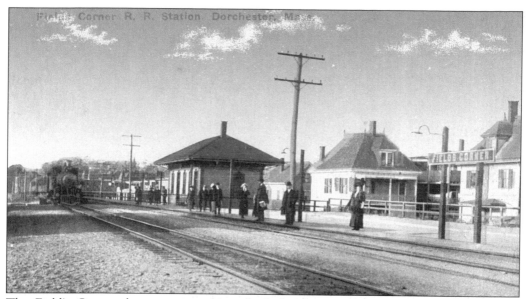

The Field's Corner depot was an elevated platform at Dorchester Avenue, just north of Faulkner Street. Field's Corner, originally known as Dalrymple Junction, was named in the 1820s for Isaac and Enos Field, two brothers who kept a general store on Dorchester Avenue, now the site of Store 24. In this view, a train approaches the depot, having just come from Shawmut Station.

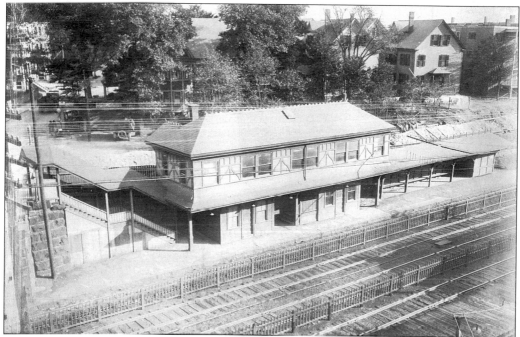

The Savin Hill depot was opposite Bay Street, seen on the left. The area was largely built up after Dorchester was annexed to Boston in 1870, after which large Victorian houses were built on the former Worthington Estate; most of the houses had a panoramic view of Dorchester Bay. The houses in the background are on Sydney Street and were photographed in 1925. (Courtesy of Frank Cheney.)

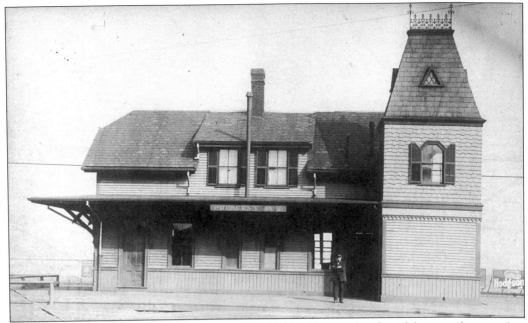

The Crescent Avenue depot was a charming wood building with a fanciful turreted tower that even boasted cast-iron crenelation. A stationmaster stands on the platform, *c.* 1890. Crescent Avenue depot is now known as J.F.K./U.Mass (or as Columbia Station to those of us old enough to know differently).

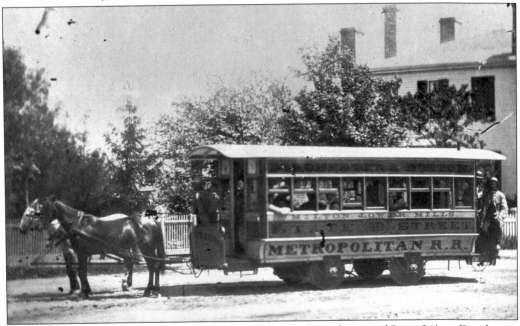

A horse-drawn streetcar passes the Field Grocery Store (now the site of Store 24) on Dorchester Avenue in Field's Corner, *c.* 1864. The Metropolitan Railroad Horsecar operated a line along Dorchester Avenue that connected the Milton Lower Mills to State Street in Boston. To travel the entire length of Dorchester Avenue took just over an hour, which seems to satisfy those passengers who had time to pose for the photographer. (Courtesy of Frank Cheney.)

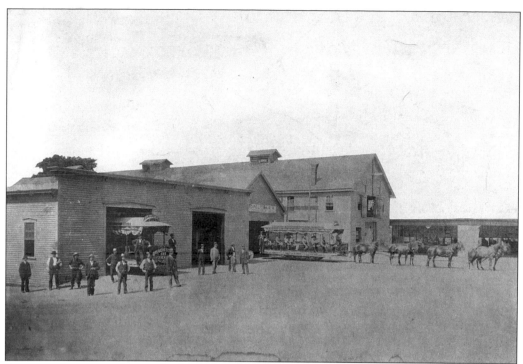

A group of men stands outside the carbarn of the Metropolitan Railroad at Field's Corner, the corner of Dorchester Avenue and Park Street. An eight-horse streetcar emerges from the carbarn on the right. In 1863, the Metropolitan Railroad Company assumed all horsecar operations in Dorchester. (Courtesy of Frank Cheney.)

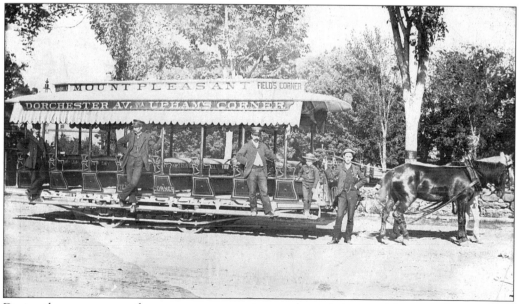

During the summer months, open cars were quite popular and pleasure riding was a big source of revenue for the railway companies. This open car was on the Mount Pleasant–Upham's Corner–Field's Corner Line when it paused under shade trees for the photographer, c. 1900. (Courtesy of Frank Cheney.)

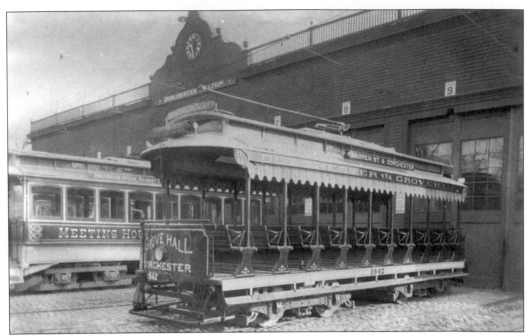

Known as Dorchester Station, the large carhouse, located at Washington and Ashmont Streets, served trolleys on the routes operating to downtown Boston via Codman Square and Meeting House Hill. This site is now occupied by the Ashmont Nursery School, the Dorchester YMCA, and the Codman Senior Citizen Apartments. This 1895 photograph shows an area of town that has changed tremendously in the last century. (Courtesy of Frank Cheney.)

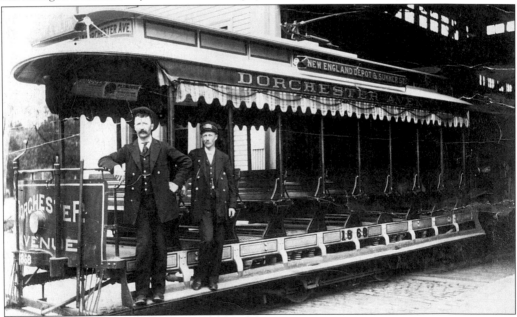

With the coming of electric trolleys to Dorchester Avenue in September 1892, the open cars referred to as "breezers" by the general public, became even more popular. Here, a car crew poses in neat blue uniforms on a new electric open car at the Field's Corner Carhouse. (Courtesy of Frank Cheney.)

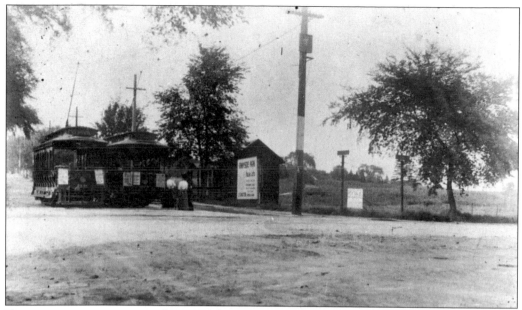

Two streetcars pass one another on Adams Street in Adams Village. The rural atmosphere of the intersection of Adams and Minot Streets remained until Sunnyside, the waiting room and store of Charles Adams, was built on the right. Today, Adams Village, named in honor of Charles Adams (1854–1926), is a thriving shopping area, with Adams Sports Shop where the pole is and Gerard's Restaurant on the right. (Courtesy of Frank Cheney.)

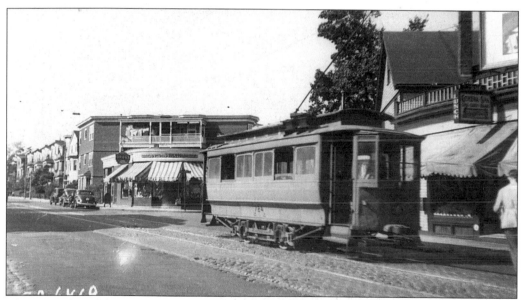

This reminder of the past is Rail-Grinding Trolley 724 smoothing rough spots off the rails on Geneva Avenue at Westville Street in September 1938. A former horsecar electrified in 1893, Trolley 724 is currently stored in a transit museum. Notice the popular Geneva Spa on the right and Brody's Pharmacy on the left. Notice the row of three-deckers on the far left, which continued to Bowdoin Street. (Courtesy of Frank Cheney.)

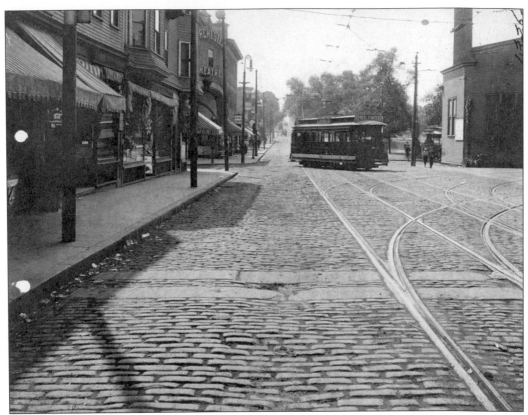

A streetcar enters the Park Street Carhouse in 1916. This car was a Field's Corner–Geneva Avenue–Meeting House Hill–Dudley Station streetcar. On the left, opposite the streetcar, is the Dorchester Theatre, at the corner of Dorchester Avenue and Park Street. (Courtesy of Frank Cheney.)

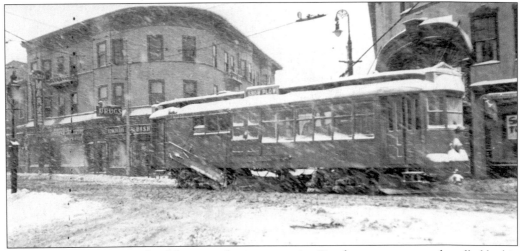

In the trolley car era, much of the snowplowing on major Dorchester streets was handled by big trolley snowplows that had been converted from disused passenger cars. One such snowplow is seen here, in 1938, on Dorchester Avenue at Park Street, passing the Dorchester Theatre on the right. (Courtesy of Frank Cheney.)

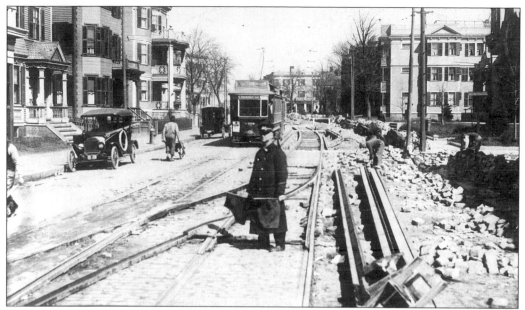

On routes with heavy trolley traffic, keeping the rails in good repair was a top priority. Here, we see a Neponset-bound trolley approaching a track repair project on Dorchester Avenue opposite St. William's Church, on the right. The church was designed by Edward Sheehan and was built in 1910. Notice the well-designed three-deckers, complete with sun blinds, corner quoins, and elaborate balustrades along Dorchester Avenue; from left to right are 1045–1043, 1041, and 1037 Dorchester Avenue. (Courtesy of Frank Cheney.)

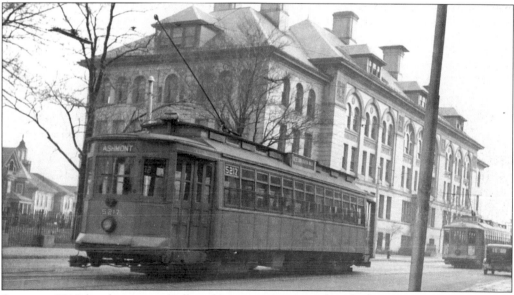

Streetcar 5217 heads west on Talbot Avenue as it approaches Codman Square in 1939. The Dorchester High School for Girls, designed by Hartwell, Richardson, & Driver and built in 1895, was at the junction of Talbot Avenue and Centre Street. The yellow brick Romanesque Revival school was later to be used as the Girls Latin School and has today been converted to apartments. On the left can be seen the cupola of the Dorchester Women's Club House, designed by A. Warren Gould (1862–1930). (Courtesy of Frank Cheney.)

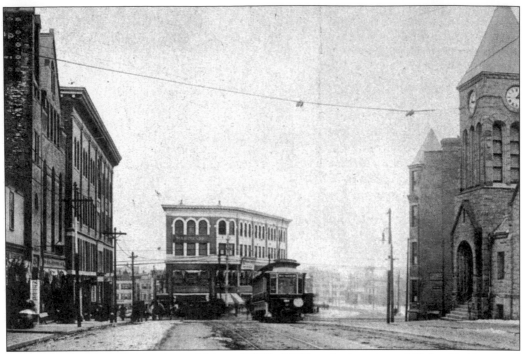

Upham's Corner, named for Amos Upham (1788–1879), is the junction of Columbia Road and Dudley, Stoughton, and Hancock Streets. A streetcar heads west on Columbia Road, where an impressive shopping area was developed between 1870 and 1900. From left to right are Winthrop Hall, the Upham Building (officially known as the Columbia Square Building), the Samuel Bowen Pierce Building, the Northwood Apartment Block, the Baker Memorial Church, and the stone wall of the Dyer Estate.

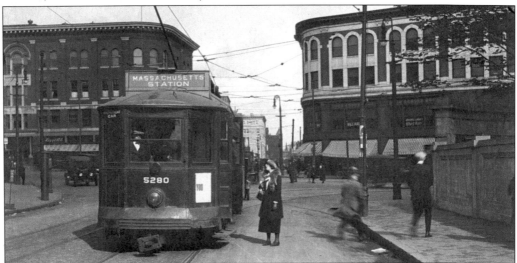

A woman with a fashionable fox stole waits to board a streetcar in Upham's Corner in 1924. The Upham Building (often referred to as the Columbia Square Building,) is on the left, and the Samuel Bowen Pierce Building is on the right. The cement-reinforced wall of the Old North Burying Ground, laid out in 1634, can be seen on the far right. (Courtesy of Frank Cheney.)

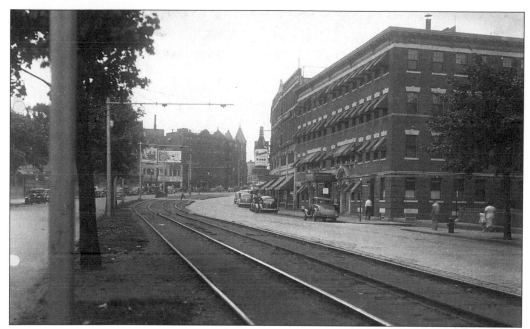

Columbia Road, originally known as Boston Street, was widened in 1893 to be a major thoroughfare connecting Franklin Park and Marine Park in South Boston. Photographed in 1938 at the corner of Hamlet Street, on the right, an impressive apartment building with summer awnings overlooks the streetcar tracks and the Old North Burying Ground. A gigantic wine bottle advertisement sign projects from the predecessor of the Purity Supreme Markets, Elm Farm Market, owned by the Cifrino Family. The Northwood and Dorchester Apartments are in the center, at the corner of Cushing Avenue. (Courtesy of Frank Cheney.)

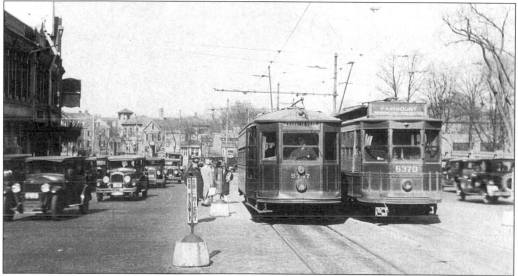

A Franklin Park-bound streetcar, left, and a Fairmount–Hyde Park-bound streetcar stop at the intersection of Columbia Road and Dudley Street in 1927. Automobiles wait patiently in line in front of Elm Farm Market for the directional in the foreground to change. Notice in the distance the stucco tower of Fire Engine 22 at the corner of Annabel Street. (Courtesy of Frank Cheney.)

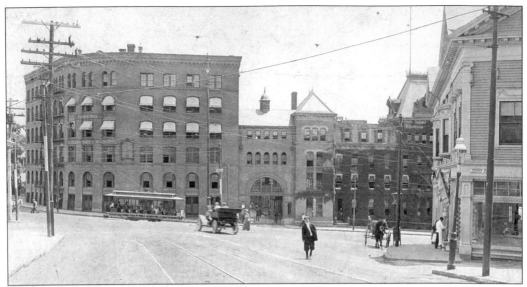

A summer streetcar travels through Pierce Square in 1898. Pierce Square, named for Henry L. Pierce (1825–1896), mayor of Boston and owner of the Baker Chocolate Company from 1854 to 1896, is the junction of Dorchester Avenue and Adams and Washington Streets. Designed by Winslow & Wetherall, the Adams Street Mill, with the awnings, was built in 1889; to its right is the Pierce Mill, designed by Bradlee & Winslow and built in 1872. On the far right is the Bispham Block, designed by Joseph T. Greene and demolished in 1982.

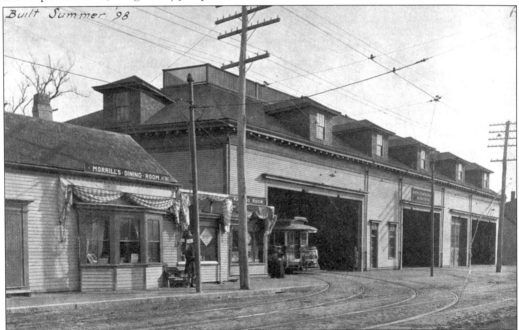

The Milton Station of the Boston Elevated Railway was a large wood building that was constructed in 1898 on Dorchester Avenue near Pierce Square. A Field's Corner-bound streetcar starts out from the station. Morrill's Dining Room was a well-known restaurant that served wholesome, home-cooked meals. The Milton Station is now the site of the Lower Mills Senior Citizen Apartments. (Courtesy of Frank Cheney.)

Pullman-built Trolley 262 was photographed in 1904 on Dorchester Avenue, with the Milton Station waiting room on the right. This streetcar connected the Lower Mills to South Station in Boston, via Dorchester Avenue through Andrew Square and Field's Corner. (Courtesy of Frank Cheney.)

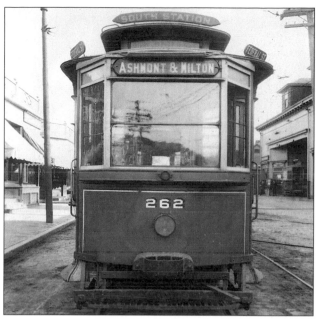

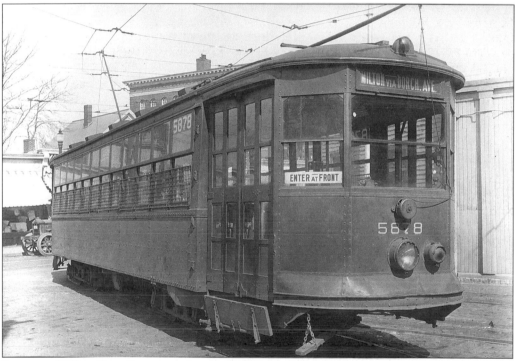

Streetcar 5878, a Type 5 car introduced in 1922, turns into the turntable of the Milton Station from Dorchester Avenue. The heavily dentilled cornice, seen just above the streetcar, is that of the Gilbert Stuart School, designed by Edmund March Wheelwright and built in 1909 on Richmond Street. Named for the famous portrait painter, the Lower Mills Branch of the Boston Public Library now stands on the site. These cars were a familiar site on Dorchester streets until 1955, when the Blue Hill Avenue Line was converted to buses. (Courtesy of Frank Cheney.)

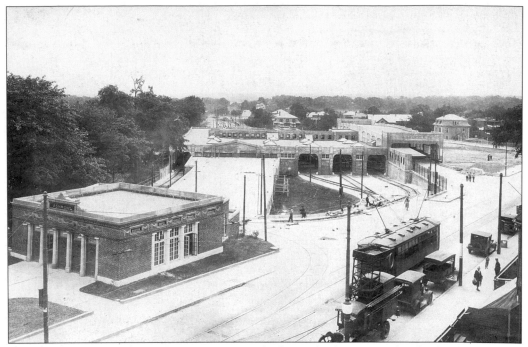

Looking toward the new Ashmont Station, which was built in 1927 for the line connecting Dorchester to Cambridge (the present Red Line), the classical red brick station entrance on the left led to the cement station seen in the distance. (Courtesy of Frank Cheney.)

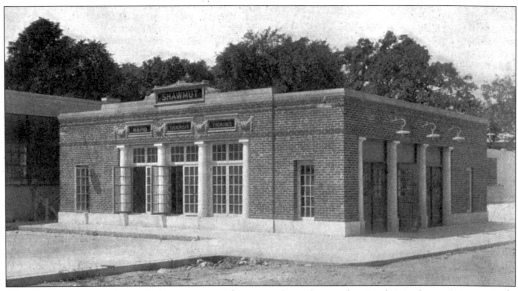

The Shawmut Station of the new rapid transit line (now the Red Line) was situated on Clementine Park; it is an impressive red brick station with classical details. Set between Centre and Mather Streets, Shawmut Station serves the quintessential streetcar suburb of Melville-Park in Dorchester.

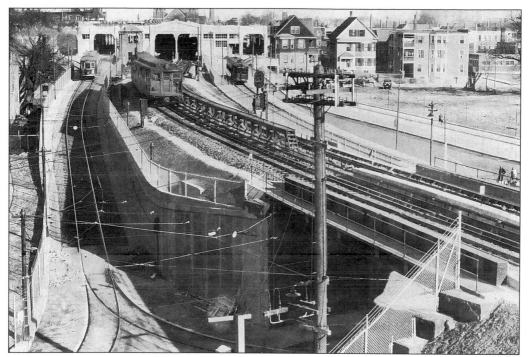

Field's Corner Station was a sprawling cement station built in 1927, spanning the area between Geneva and Dorchester Avenues. A train heads south towards Shawmut Station, with streetcars entering on the right and leaving the station on the left. The houses on the right are on Faulkner Street. (Courtesy of Frank Cheney.)

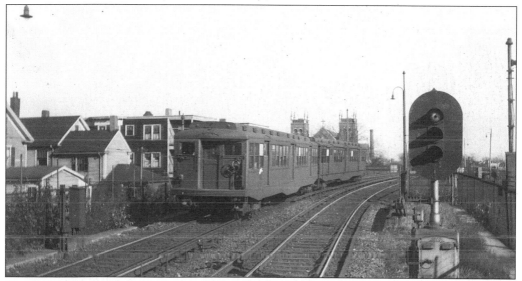

During 1928 and 1929, the Boston Elevated converted the Shawmut Branch Commuter Rail Line of the Old Colony Railroad to modern electric rapid transit, operating to Field's Corner, Shawmut, Ashmont, and Mattapan. This train approaches Field's Corner Station from Savin Hill Station in 1943. In the distance are the twin spires of St. Ambrose Church on Adams Street, designed by W.H. McGinty, and on the left are houses on Charles Street. (Courtesy of Frank Cheney.)

79

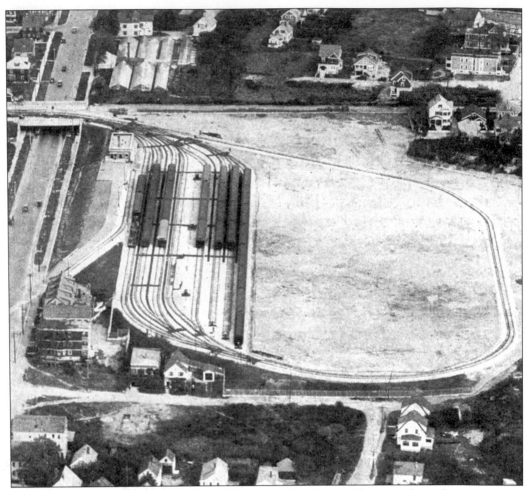

The Codman Street Yard was the holding area for the rapid transit line that connected Dorchester and Cambridge. Gallivan Boulevard (Route 203), seen on the left, was originally known as Codman Street; however, in 1927, this open area in Cedar Grove was developed for side tracks and a repair station. Widened and straightened in 1927, the new boulevard was named for James Gallivan (1866–1928), a representative in 1895 and 1896 and a state senator in 1897 and 1898. Gallivan later served as street commissioner in Boston from 1900 to 1914; one of Dorchester's busiest highways was named in his memory. The greenhouses on the upper left were at the corner of Gallivan Boulevard and Rangely Street. On the far right Milton Street can be seen, and in the immediate foreground is Hutchinson Street.

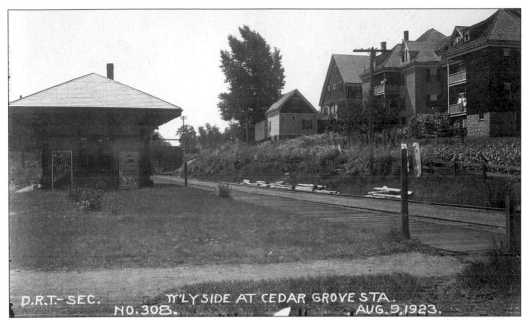

The Cedar Grove Station was a small wood-framed depot that was built in the 1870s and was originally part of the Shawmut Branch of the Old Colony Railroad. In December 1929, it became a stop on the high-speed surface trolley line that connected Ashmont and Mattapan Stations. The houses on the right are on Hillsdale Street. (Courtesy of Frank Cheney.)

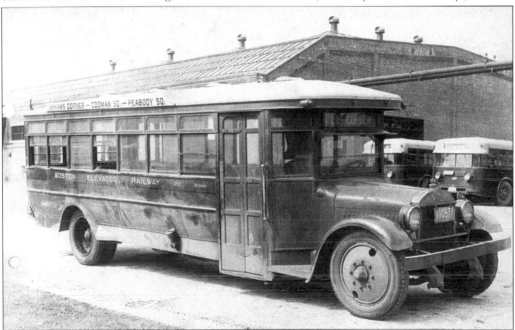

For many years, the most heavily used and convenient bus route in Dorchester was the Belt Line, which circulated through Ashmont, Savin Hill, Field's Corner, Upham's Corner, and Codman Square. In 1929, the passengers traveled in this 1926-model bus, built by the Mack Motor Company, which by 1925 had replaced all trolleys in Dorchester. (Courtesy of Frank Cheney.)

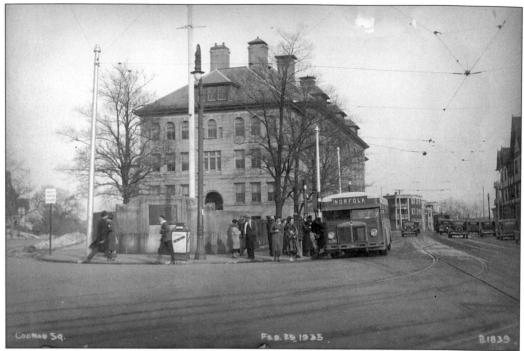

In this February 1935 photograph, passengers crowd aboard a Norfolk Street bus at Codman Square in front of Dorchester High School for Girls, which was designed by Hartwell, Richardson, and Driver and was built in 1895. The Tudor-style apartment house on the right was known as the Shakespeare and was destroyed by fire in 1971. The former school has been converted to apartments. (Courtesy of Frank Cheney.)

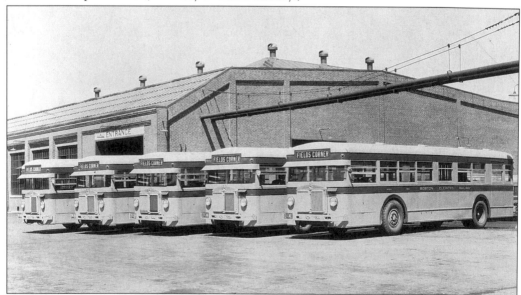

In 1932, the Boston Elevated decided that it needed larger buses on its routes in Dorchester and turned to the Mack Motor Company to provide the required vehicles. These new Mack buses are lined up at the Field's Corner Bus Garage in August 1932. The buses were phased out in 1946, and the garage was demolished for a shopping mall in 1964. (Courtesy of Frank Cheney.)

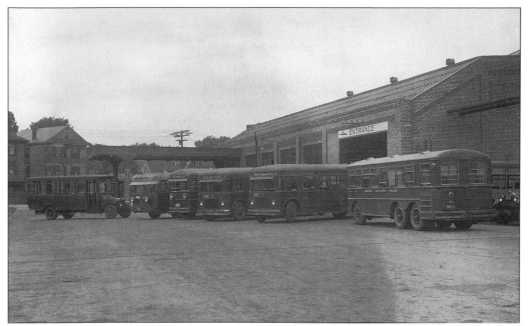

Dorchester Transit passengers rode in buses provided by a number of manufacturers, as seen in this view at the Dorchester Garage at Field's Corner in June 1929. Lined up for the photographer are buses from Mack, Twin Coach, American Car & Foundry, and Vesare. The bus garage is now the site of a shopping mall, and the three-deckers on the left on Geneva Avenue still stand. (Courtesy of Frank Cheney.)

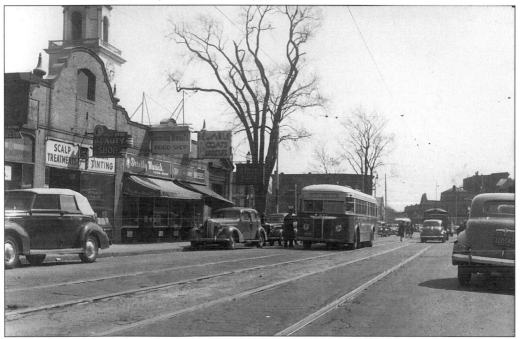

An Upham's Corner-bound bus stops for a passenger in Codman Square at the corner of Washington and Moultrie Streets, c. 1942. The spire of the Second Church in Dorchester rises above the Flemish, gabled storefronts on the left. (Courtesy of Frank Cheney.)

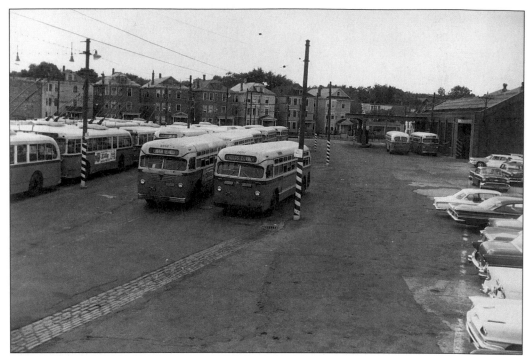

The Field's Corner Carhouse was on Park Street, bounded by Geneva and Dorchester Avenues. Buses are parked on the left; drivers' cars are parked on the right. This location now hosts the shopping mall in Field's Corner, built in 1964. The early three-deckers in the background were built c. 1900 on Geneva Avenue between Park and Vinson Streets. (Courtesy of Frank Cheney.)

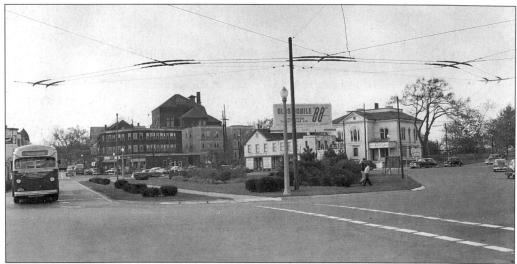

A bus from Field's Corner approaches Neponset Circle from Neponset Avenue, c. 1949. Wood Hall, the Italianate building on the right, was designed by Luther Briggs Jr. and was built in 1856, when this neighborhood was known as Port Norfolk. The tall building on Neponset Avenue, in the center, was the Minot School, named for the family who once owned the land; it is now the site of the Neponset Health Center. Now Neponset Circle, the Southeast Expressway cuts a wide swath through the center. (Courtesy of Frank Cheney.)

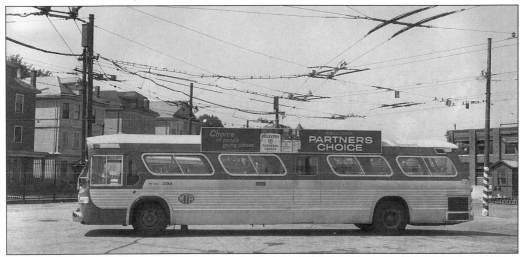

In the summer of 1962, Dorchester received a fleet of 125 new General Motors New Look type buses, which replaced all the quiet, fume-free electric trolleys, which had soft leather seats. The new buses, such as this one seen at Field's Corner, had hard plastic seats, excess fumes, and diesel vibrations—all of which drove many riders to buy automobiles, rather than to endure a hard ride. (Courtesy of Frank Cheney.)

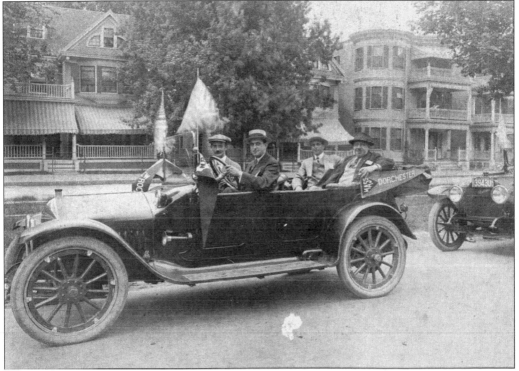

A foursome travel west on Columbia Road *c.* 1920 in an open touring car during Dorchester Day festivities. The house on the left, 670 Columbia Road and its mate at 674 are Queen Anne houses, built *c.* 1885. On the right are three-deckers at 676 and 678 Columbia Road, part of a row which was built between 1900 and World War I, creating a uniform streetscape of three-deckers along Columbia Road at Edward Everett Square.

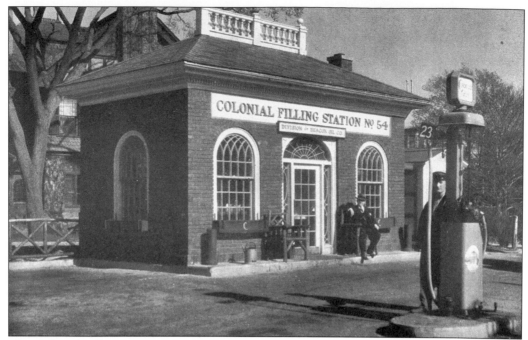

The Colonial Filling Station No. 54 was an elegant Colonial Revival, red brick gas station at the corner of Washington and Tremlett Streets. A gas station attendant stands beside a pump proclaiming fuel at 23¢ per gallon. Notice the rustic wood chairs on either side of the door, which seem quite comfortable to the customer seated on the right.

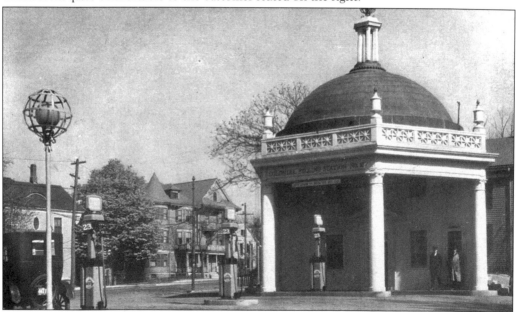

The Colonial Filling Station No. 27 was photographed by the noted architectural photographer Paul Webber in 1926. Located at King Square in the triangular lot between Neponset Avenue, on the left, and Adams Street, this elaborate gas station had columns supporting a red dome with an orbit as a finial. In the doorway on the right are men in the long leather coats—the typical driving coat of the period.

Four

FRANKLIN PARK

Originally known as West Roxbury Park, Franklin Park is the largest open area in the city of Boston. Composed of seven farms that were incorporated into a single open space in the 1880s, the new park was named for the printer, diplomat, scientist, inventor, and great statesman Benjamin Franklin (1706–1790), who bequeathed to the town of Boston a sum of money that upon his death was prudently invested and used a century later to found the Franklin Institute in Boston's South End and to purchase Franklin Park and Franklin Field, just to the south on Blue Hill Avenue.

Often referred to as the Jewel in the Emerald Necklace that surrounds Boston, this 527-acre park was designed by Frederick Law Olmstead as a bucolic green space that was located in Dorchester and Roxbury, once separate towns that were annexed to the city of Boston in 1870 and 1867 respectively. The impressive aspect of Franklin Park was described by Olmstead as having "the usual characteristics of the stony upland pasture, and the rocky divides between streams commonly found in New England, covered by what are called 'second growth' woods . . . not beautiful individually, but, in combination forming impressive masses of foliage." This open land was to include distinct areas such as Scarboro Hill, Schoolmaster's Hill, Hagborne Hill, Juniper Hill, Abbotswood, Ellicottdale, and the Greeting as one approached the park from Blue Hill Avenue. The park was to have broad expanses of lawn with dense plantings of trees that not only created a pleasing, somewhat curative, natural landscape, but also a place where the public could enjoy recreation, such as tennis and golf. Olmstead's vision for Franklin Park was that its highest value "must be expected to lie in elements and qualities of scenery to which the mind of those benefiting by them, is liable, at the time the benefit is received, to give little conscious cogitation."

By the early 20th century, Franklin Park could proudly boast the first public golf course in the United States. Laid out in 1890 by George Wright, a partner in the sporting goods firm of Wright & Ditson, and his friend John Smith, the nine-hole golf course had tin cans for holes and a yardstick fashioned with red flannel pennants for flags. This crude, makeshift golf course at Franklin Park was described in *Fifty Years of American Golf* as hosting "undoubtedly . . . the first game of golf ever played in a public park in this country." Within a short period of time, the game of golf had become so popular that a professional 18-hole course was laid out on the great expanse known as the Country Park. Enjoyed by generations of Bostonians in the ensuing years, Franklin Park's golf course recently underwent extensive renovations, which will ensure its place in history.

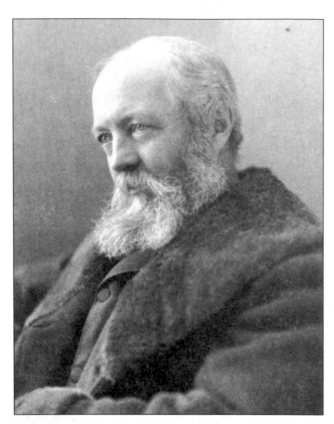

Frederick Law Olmstead (1822–1903) created Boston's Emerald Necklace, with Franklin Park as the crown jewel, beginning in 1884. His green belt of tree-shaded roadways, the first park system in this country, extended from the Public Garden in the Back Bay through the Fens and Jamaica Plain to the open dells and valleys named Franklin Park in honor of Benjamin Franklin, whose bequest to Boston allowed the purchase of the land. Today, though his designs for Franklin Park were never fully realized, the open green space still beckons us with living art.

Sheep graze in Franklin Park in 1915 with a stand of trees in front of a wide vista. The quaint aspect of a flock of sheep within walking distance of residential neighborhoods made Franklin Park not only unique but also a popular destination on a weekend to admire Olmstead's 527-acre masterpiece that he referred to as the Country Park.

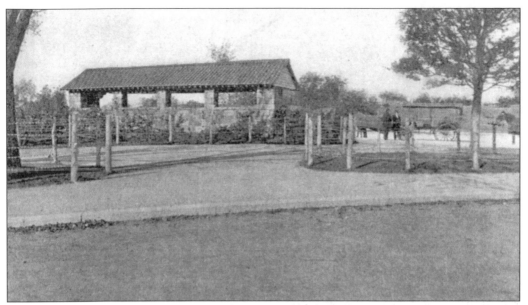

The Phaeton Station at Franklin Park was built as a rustic structure of rough-hewn stones with a large-tiled roof for the protection of horses. A phaeton, a light four-wheeled, horse-drawn carriage, can be seen on the right, with the coachmen standing by the horse and Blue Hill Avenue in the foreground. This station still stands opposite Columbia Road and is used as a waiting area for buses.

The main driveway and bicycle path at Franklin Park was a serpentine road that began at Blue Hill Avenue and curved through sections of the park known as Abbotswood, Hagborne Hill, Ellicottdale, and Juniper Hill, terminating opposite the Forest Hills Cemetery. With stands of trees and boulders set in a naturalistic manner, Franklin Park had a peaceful and bucolic quality in a rapidly developing city.

The Children's Knoll at Franklin Park was a gentle sloping hill with pergolas and a trellis-covered terrace on the crest of the hillock where children and their parents could sit and enjoy the views. Two men stand by a stone wall in the foreground with open fields stretching in either direction.

The Overlook at Franklin Park was a long, low stone lodge with a massive roof that was punctuated by a stone chimney. Set in the landscape as part of the whole, the Overlook was a popular destination for hikers at Franklin Park, especially on cold winter days when a roaring fire blazed in the open fireplace. Notice the large flat rocks and massive boulders that were part of the glacier deposits that Olmstead incorporated into the naturalistic landscaping.

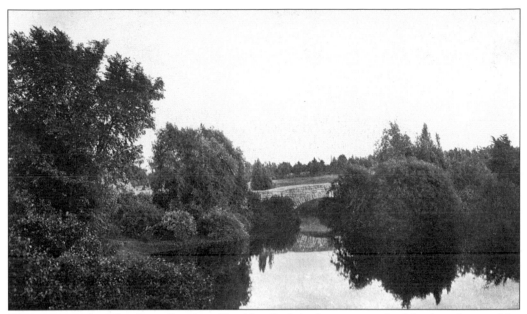

The upper end of Scarboro Pond at Franklin Park had a stone-arched bridge, designed by Richardson's firm, that spanned the river. With lush foliage and trees on either side of the bridge, the creation of green space at Franklin Park was not only successful but also looked as if it had developed naturally rather than having been planned.

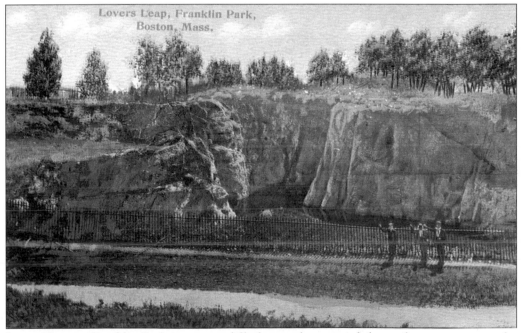

Lovers' Leap at Franklin Park is a steep cliff of stone that created the perfect spot to atone for unrequited love. Though there is no record to indicate that this was the site of a lover's ultimate test of love, it was still a popular place to take one's date at the beginning of the 20th century.

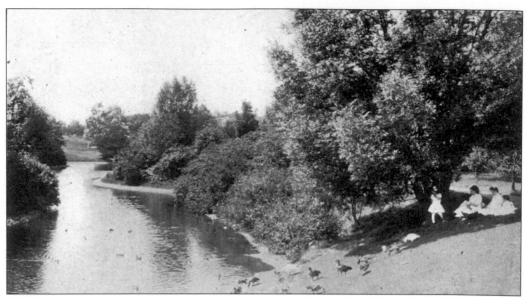

Four pinafored girls feed the ducks at Scarboro Pond in Franklin Park, c. 1905. The bank gently sloped down to the water and provided the perfect place to throw bread to the obliging ducks. This area, bound by Scarboro Hill and Canterbury Hill, was a lush tree-studded area.

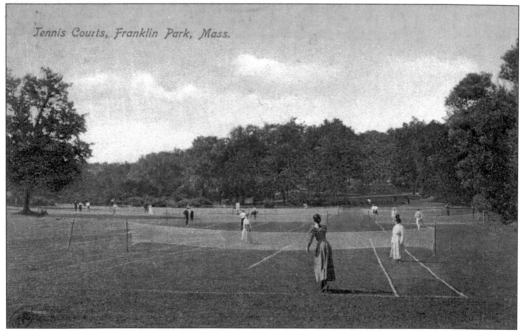

Tennis Courts, Franklin Park, Mass.

Competition is keen as these friends play lawn tennis at the Ellicottdale Tennis Grounds at Franklin Park. These courts were grass rather than clay, and the quaint outfits of these tennis players are quite different from the tennis whites of the mid-20th century.

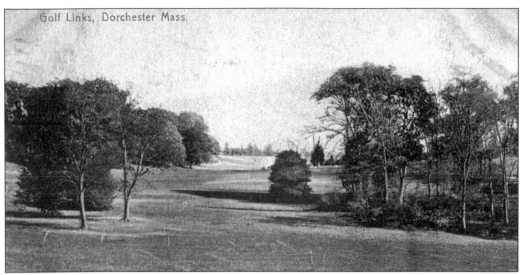

Golf Links, Dorchester Mass.

The Golf Links at Franklin Park were laid out on the Country Park in 1890 by George Wright, a partner in the sports firm of Wright & Ditson in Boston. With his friend John Smith, Wright "laid out holes with a yardstick fashioned with a red flannel pennant for flags. With this crude, makeshift course, Wright and a group of friends enjoyed the first game of golf in Boston" at Franklin Park—and so created golf's journey from Scotland to the United States.

Robert Lamprey proudly poses beside a framed photograph of his illustrious grandfather, the noted golfer Willie Campbell (1862–1900), who was born in Musselburgh, Scotland. Campbell had been induced to come to Boston in 1894, where he became the first professional golf instructor at the Country Club in Brookline, extending the layout of the rudimentary course that existed. He also became the professional golf instructor at the Franklin Park in 1896, convincing the city to lay out professional links at the park, augmenting Wright's vision. Following his death, his widow, Georgina Campbell, was appointed by the city as golf professional at Franklin Park. (Courtesy of Brian DeLacey with thanks to Robert Lamprey.)

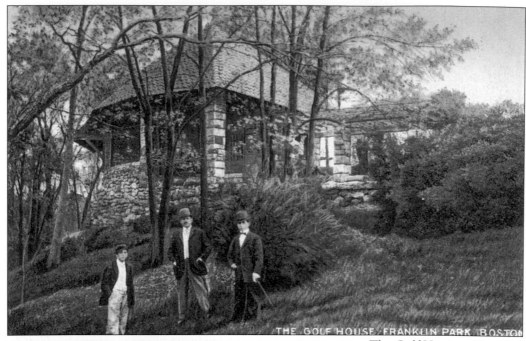

THE GOLF HOUSE, FRANKLIN PARK, BOSTON

The Golf House at Franklin Park was a stone lodge with a massive roof that was designed by Edmund March Wheelwright (1854–1912) as a place for golfers to relax after 18-holes at Franklin Park. A trio of golfers stand on the walkway to the Golf House in 1910; today, the golf course at Franklin Park is known as the William J. Devine Golf Course; it had a major overhaul in the 1990s.

Golfers at the turn of the century dressed in tweed caps, shirts and ties, and often wool knickers. Here, a golfer prepares to take a swing on the fairway with a fairway wood. It is interesting to note that both Willie and Georgina Campbell made golf balls and clubs for a generation of new golfers at Franklin Park.

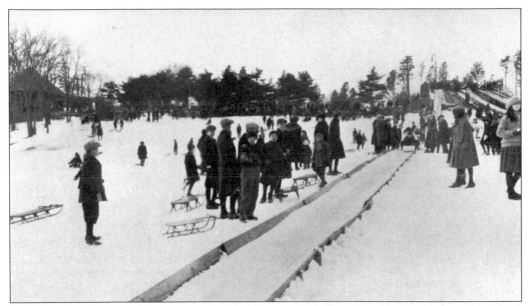

Young adults enjoy tobogganing on Schoolmaster's Hill at Franklin Park in 1923. Here, a toboggan run has been laid out and iced for a swift ride down the hill from the toboggan chutes set up on the far right. Notice the Golf House on the left; it was designed by Edmund March Wheelwright.

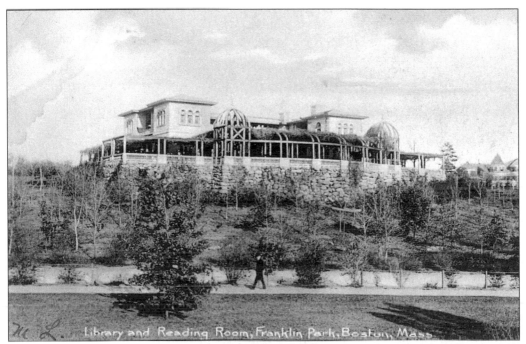

The Library and Reading Room at Franklin Park were in a massive building on Refectory Hill overlooking Blue Hill Avenue. Here, the Boston Public Library opened a branch library for the patrons living in the vicinity of Franklin Park. The naturalistic plantings, stone outcroppings, and the stone walls and foundation all harmonized with Olmstead's great creation of a natural park within the city. The houses on the right are at Blue Hill Avenue and McLellan Street.

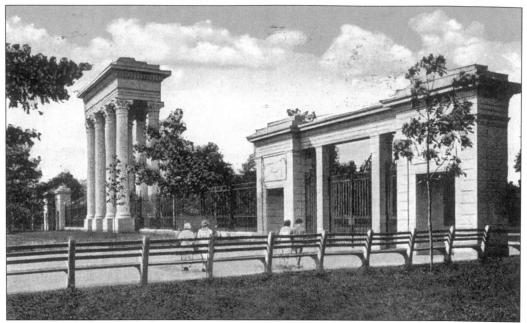

The Greeting, otherwise known as the monumental entrance to Franklin Park, was built in 1915, utilizing eight of the interior Corinthian columns from the Boston Custom House for a triumphal archway. The addition of a tower to Boston's Customhouse in 1915 by Peabody and Stearns was the city's first skyscraper; the removal of the rotunda allowed for the reuse of these columns for a dramatic effect at Franklin Park.

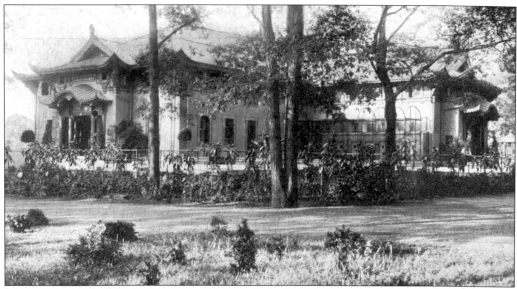

The Aviary at Franklin Park was designed by city architect Edmund March Wheelwright (1854–1912) as a fantastic Chinese-inspired stucco building with a red-tiled roof with upturned corners. The Aviary had birds of every description, all of which obligingly chirped for their admiring audiences. Today, the African Tropical Rain Forest re-creates the now lost Aviary as a destination of note at Franklin Park Zoo.

The crenelated Stone Tower at Franklin Park was built near the Rose Garden in the Long Crouch Woods section that perpetuated the name of the estate of Ebenezer Seaver, a member of Congress from 1803 to 1813 and for whom Seaver Street was named. This area ran parallel to Seaver Street on the Roxbury side of Franklin Park, and had fanciful "ruins" such as this tower made from stones and pieces of pudding stone gathered on the site. Near this tower was the Deer Park and Sergeant's Field.

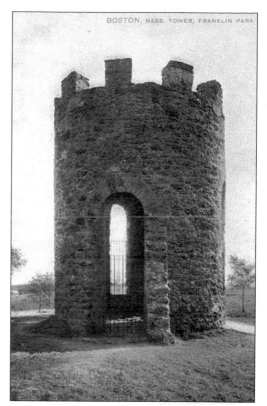

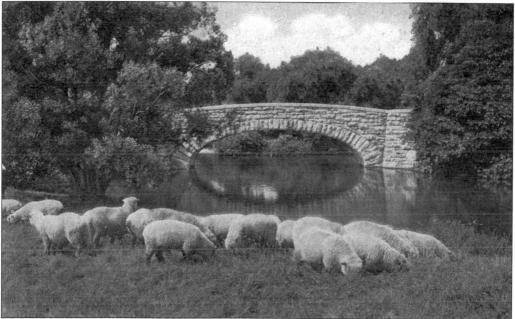

This scene poignantly depicts the wide appeal of Franklin Park in the early 20th century. With a flock of sheep grazing on the banks of Scarboro Pond and a stone arch spanning the banks of the pond, the quaint and bucolic quality of Olmstead's landscaping retains its appeal a century later.

In the 1870s, Mattapan Square was a country crossroads, with River Street connecting the Lower Mills and Hyde Park—a section of Dorchester that was incorporated in 1868 as an independent town. The James Boies House, on the right, was the typical dwelling one saw in this area; Boies led the patriots who fortified Dorchester Heights in 1776 during the American Revolution. Boies was John McLean's partner in the Boies & McLean Paper Mill in Unquityquisset, or the Upper Falls, as Mattapan was known by the Neponset tribe of the Massachusetts Indians.

Brush Hill Turnpike, as Blue Hill Avenue was originally known, was laid out in 1805 as a turnpike road connecting Roxbury with towns to the south. One paid a toll at stations along the road; the tollhouse at the corner of River Street can be seen on the left. This view, looking north on Blue Hill Avenue c. 1870, remained rural until the early years of the 20th century, when large-scale development took place.

Five
ALONG BLUE HILL AVENUE

Blue Hill Avenue is one of the longest and busiest thoroughfares in Dorchester. Laid out by the Brush Hill Turnpike Corporation in September 1805 as the Brush Hill Turnpike, it connected the town of Roxbury and the upper mills at Mattapan, known as Unquityquissett by the Neponset tribe of the Massachusetts Indians, and today known as Mattapan Square. Crossing today through a densely built up area composed of residences and businesses, Brush Hill Turnpike was named for Brush Hill, a lesser hill in Milton, Massachusetts, in the Blue Hills range, that can be seen as one travels south from Franklin Park. The streetscape includes the bucolic Franklin Park and Franklin Field, both named after Benjamin Franklin, as well as a wide array of housing from single-family houses to three-deckers, two-family houses, and apartment buildings. By the mid-19th century, this area was serviced by horse-drawn streetcars, which were later electrified, and even later replaced with buses that provided ease of transportation to and from Boston and allowed the continued development of the popular residential area.

As a turnpike road, the turnpike eventually failed and was opened as a public street when the proprietors of the Brush Hill Turnpike Corporation relinquished the franchise of the corporation on October 15, 1856. The new public way, which extended through a largely undeveloped area of Dorchester, was renamed Blue Hill Avenue on October 25, 1870, the same year that Dorchester was annexed to the city of Boston.

In the decade prior to 1870, the land along Brush Hill Avenue was primarily owned by large landowners, among them Eliza Floyd (30 acres), Frederick Gleason (12 acres), George W. Goodale (12 acres), George W. Grant (4 acres), Ellis Houghton (18 acres), Isaac McLellan (14 acres), Clement Sumner (11 acres), Asa Thompson (11 acres), John N. Tileston (50 acres), William Wellington (109 acres), and Marshall Pinckney Wilder (26 acres). Between 1870 and World War I, these open lands flanking Blue Hill Avenue were developed; new streets were laid out, and a large number of new houses were built. From elegant one-family houses such as those built on McLellan, Charlotte, Esmond, Wales, and Abbott Streets to three-deckers and two-family houses along the flat of the street on either side of Morton Street, the wide array of housing stock is evident in the rapid development of Dorchester in the five decades following the annexation. Today, Blue Hill Avenue is one of Dorchester's major thoroughfares that connects all parts of the city to the south and west from Dudley Street to Mattapan Square.

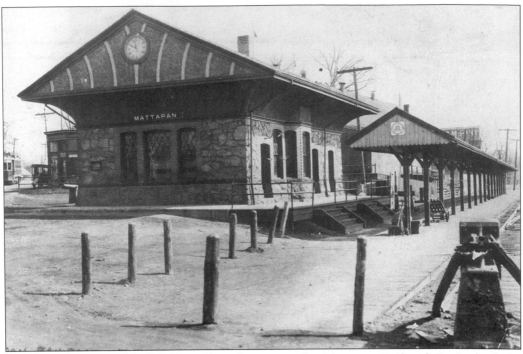

The Upper Falls Railroad Station (later known as the Mattapan Railroad Station) of the Shawmut Branch of the Old Colony Railroad was photographed in 1924. Built at the corner of River Street and Blue Hill Avenue, the station was the terminus at Mattapan Square, and is now used as a pizza parlor. Notice the trolley, on the far left, approach the square from River Street. (Courtesy of Frank Cheney.)

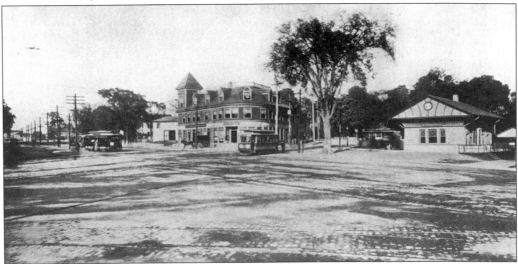

In 1900, Mattapan Square was a major crossroads with River Street, Blue Hill Avenue, Blue Hill Parkway, and Brush Hill Road intersecting in the foreground. On the right is the Mattapan Railroad Station at the corner of River Street; in the center is the Burt Block, built in 1893 by the Burt Brothers, who were well-known builders in Mattapan, Dorchester, and Milton in the late 19th century. Two streetcars approach Mattapan Square, ensuring ease of transportation for commuters and shoppers alike.

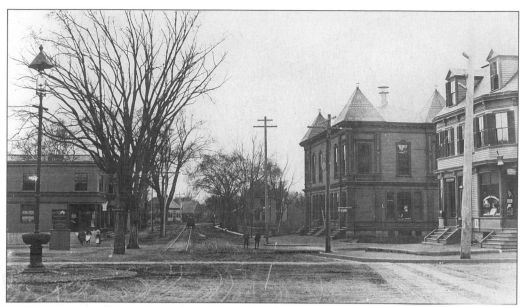

Looking west on River Street from Blue Hill Avenue at Mattapan Square in 1895, these commercial buildings were built for the numerous businesses opening to serve the residents of the area. The building on the right with the pyramidal roofs is Oakland Hall, a community meeting place, and the predecessor of the Mattapan branch of the Boston Public Library. Oakland Hall was demolished when Cummins Highway, named in 1929 for Rev. John F. Cummins (1853-1933) of the Sacred Heart Church in Roslindale, was laid out. On the far right is the Mattapan Post Office. (Courtesy of Kevin Farrell.)

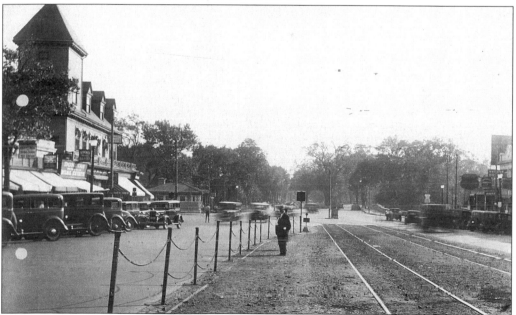

Looking south on Blue Hill Avenue at Mattapan Square in 1931, a gentleman stands at the streetcar stop for a Boston-bound streetcar. The grand turreted and dormered building on the left was the Burt Block, built in 1893 by John and George Burt, well-known builders and contractors whose plant was on Blue Hill Avenue in Mattapan. (Courtesy of Frank Cheney.)

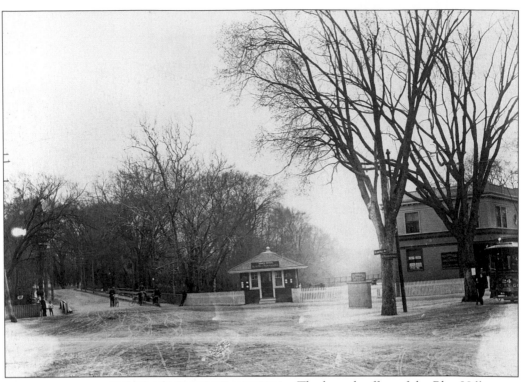

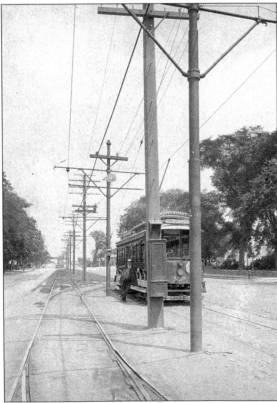

The branch office of the Blue Hill Terrace Company was perched on the edge of the Neponset River at Mattapan Square, as seen in this photograph from 1895. A Norfolk Suburban streetcar approaches the square from Readville, with the conductor stopping for the photographer; the building on the right is the Riverside Pharmacy. The children on the left stand on what is now the approach to Blue Hill Avenue and Brush Hill Road in Milton. (Courtesy of Kevin Farrell.)

The conductor of Open Car 3086 poses jauntily on Blue Hill Avenue near Mattapan Square in 1904. This streetcar serviced the Mattapan–Warren Street–Dudley Station Line and passed through parts of Mattapan that remained undeveloped until the 1920s. In the distance can be seen the bridge of the Midlands Division Railroad, formerly the Boston, Hartford, & Erie Railroad, now depressed under Blue Hill Avenue at Woodhaven Street. (Courtesy of Frank Cheney.)

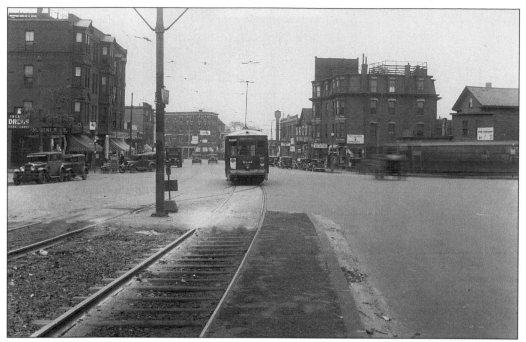

Streetcar 5942 approaches Grove Hall from Warren Street in Roxbury in 1932. Blue Hill Avenue, at Grove Hall, separates Roxbury, on the left, and Dorchester, on the right. Grove Hall was named for the estate of Thomas Kilby Jones, which was built *c.* 1810 on Blue Hill Avenue between Washington and Seaver Streets. This estate later became the Cullis Consumptive Home. (Courtesy of Frank Cheney.)

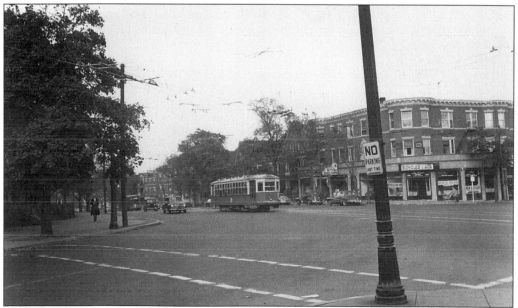

Blue Hill Avenue, at the junction of Columbia Road on the right, was a busy intersection, opposite Franklin Park. A Type 5 Car 5756 was photographed in 1949, heading south towards Mattapan Square. Notice the wood houses set between the large apartment buildings along Blue Hill Avenue. (Courtesy of Frank Cheney.)

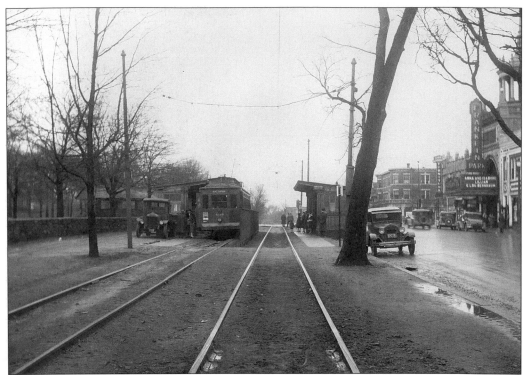

A streetcar stops on Blue Hill Avenue, in 1932, opposite the Franklin Park Theatre. An elaborate theatre with a fantastic columned cupola, it overlooked Franklin Park and often offered movies in Yiddish for the large Jewish population that lived in the neighborhood. Notice the Phaeton Station designed by Olmstead on the far left—at this time, it had become an open-air waiting station for passengers awaiting streetcars. (Courtesy of Frank Cheney.)

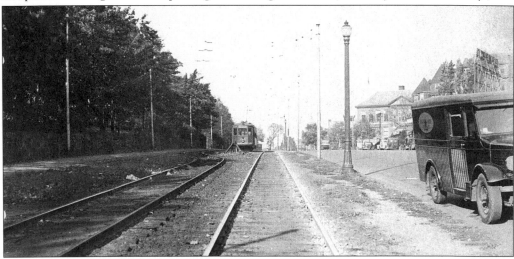

A streetcar heads south on Blue Hill Avenue in 1938, opposite Franklin Park. On the right can be seen the William Endicott School at the corner of McClellan Street. Designed by James E. McLaughlin and built in 1906, the school was named for William Endicott (1842–1903), master of the Christopher Gibson School on School Street in Dorchester for over four decades. (Courtesy of Frank Cheney.)

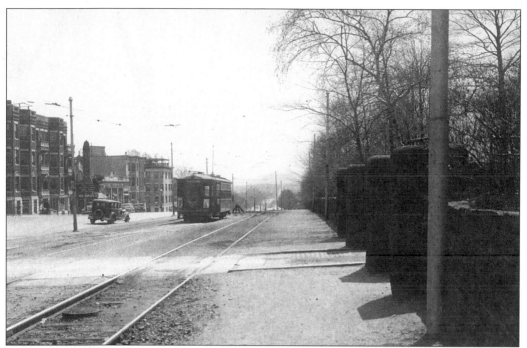

Blue Hill Avenue passes Franklin Park; the stone gates to the Library and Reading Room can be seen on the right. The grand apartment buildings on the left were built just after World War I for Dorchester's burgeoning population. The apartment building on the far left at the corner of Charlotte Street had superb views of the park and accessibility to town by the streetcars along Blue Hill Avenue. Notice the marquee of the Liberty Theatre, just to the right of the apartment building. (Courtesy of Frank Cheney.)

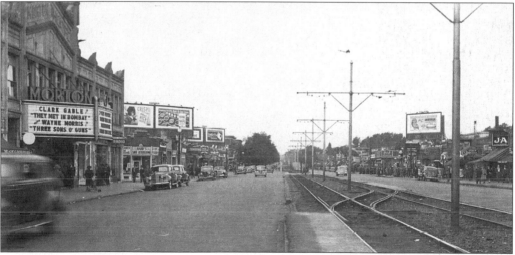

Looking north on Blue Hill Avenue from Morton Street in 1941, the Morton Theatre can be seen on the left with an advertisement for *They Met In Bombay* and *Three Sons O' Guns*. The numerous stores along both sides of Blue Hill Avenue offered every sort of goods needed by housewives. The Morton Theatre is now the site of the Dorchester-Mattapan Police Station. Notice the famous G&G Deli on the right, at the corner of Woodrow Avenue, the site of many election eve rallies. (Courtesy of Frank Cheney.)

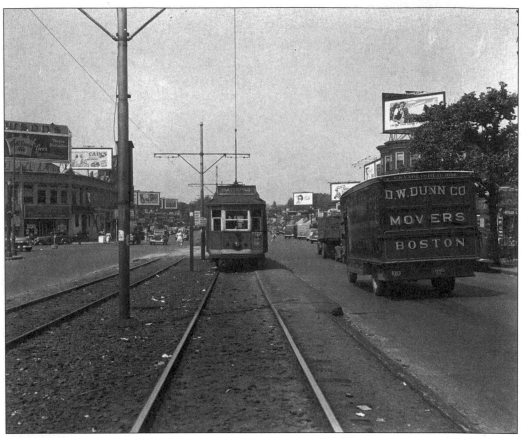

A Mattapan streetcar heads north on Blue Hill Avenue, approaching the junction of Morton Street in 1946. (Courtesy of Frank Cheney.)

St. Angela's Parish was established in 1907, two decades after the first Mass was said in Oakland Hall in Mattapan Square. The lower church was designed by F.F. Houghton, successor to Patrick J. Keely, and completed in 1909; the upper church was designed by Maginnis and Walsh and completed in 1916. The rectory, just to the right of the church, was constructed in 1926.

The interior of St. Angela's Church is an impressive space with seating for 1,100 people. Dedicated by William Cardinal O'Connell on June 1, 1919, St. Angela's was an anchor in the neighborhood, which in the decades prior to World War II became a neighborhood with a large Jewish population.

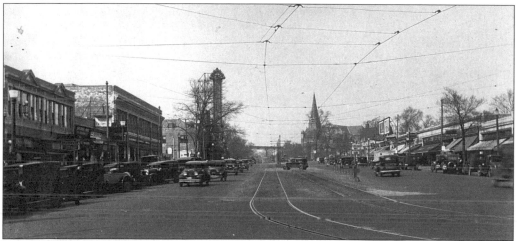

Mattapan Square, looking north, had numerous commercial blocks built in the period from 1910 to 1930. During this time, Dorchester's population doubled, with just over 200,000 residents calling the neighborhood home by the time this photograph was taken in 1931. The marquee of the Oriental Theatre can be seen on the center left and the spire of Saint Angela's Church on the right. Notice the spiderweb-like overhead lines for the operation of the streetcars. (Courtesy of Frank Cheney.)

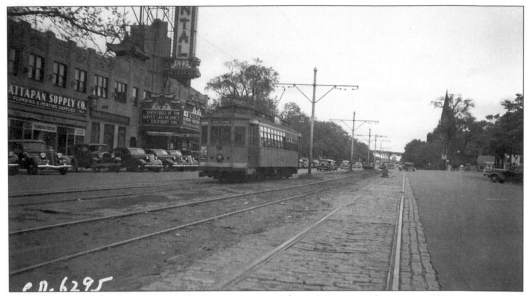

A streetcar travels along Blue Hill Avenue approaching Mattapan Square in 1938, passing the Mattapan Supply Company and the Oriental Theatre, which is playing *The Adventures of Tom Sawyer* and *Everybody Sing*. On the right can be seen the spire of St. Angela's Church, at the corner of Fremont Street. (Courtesy of Frank Cheney.)

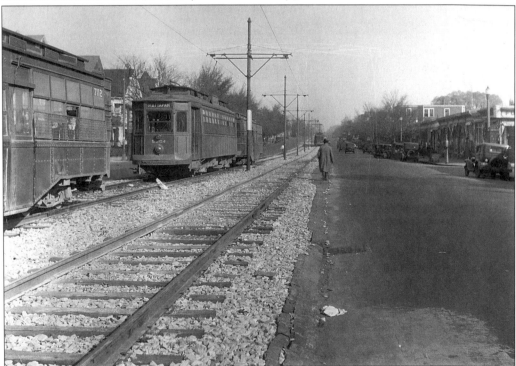

Two streetcars head south on Blue Hill Avenue towards Mattapan Square. A man walks along the gravel rail bed; on the right are stores at the corner of Balsam Street. The frequency of these trolleys meant that Mattapan was not only a convenient place to live but also within commuting distance of Boston. (Courtesy of Frank Cheney.)

Six

THE CARNEY HOSPITAL

The Carney Hospital is a vitally important medical facility that provides medical attention not only to those living in Dorchester but also to residents throughout the metropolitan Boston area. Founded in 1863, the purpose of the Carney Hospital is to provide medical attention to a rich diversity of people for a variety of primary care needs and specialized services, just as it did over a century ago. Through the generosity of Andrew Carney (1794–1864), a retired partner in the clothing firm of Carney and Sleeper, Carney Hospital began in South Boston with a total of 53 patients "as a hospital where the sick without distinction of creed, color or nation shall be received and cared for; and that no patient within its walls be deprived of his or her minister."

For over 90 years, the Sisters of Charity of St. Vincent de Paul ministered to the poor, the ill, and the forgotten. Sister Ann Alexis (1805–1875) began as administrator of the Carney Hospital at the request of Andrew Carney in 1863 and continued for seven years. Known as the Servant of the Poor, Sister Ann Alexis had been persuaded to come to the first Catholic hospital in New England, where she commenced the organization of the Carney Hospital. Upon her death, her eulogy extolled her dedication in that it "will go on when she shall be gathered to her reward; but like all original and enthusiastic workers in the cause of mankind, her influence will extend down the ages, and thousands who will never know her name will yet feel the benefit of her good and zealous labors."

The great strides that took place at the Carney Hospital since its founding in 1863 include the first ovariectomy surgery in Boston in 1882 by Henry I. Bowditch, M.D.; the first abdominal surgery in the United States, performed by John Homans, M.D., in 1882; the first skin clinic in Boston in 1891; the first Catholic nursing school in New England in 1892, the first graduating class being in 1894; the first hospital in New England to have permanent chiefs in medicine and surgery with Henry Christian, M.D., named physician in chief in 1907 and John C. Munro, M.D., surgeon in chief; the first plastic hip operation in the United States, performed by W.R. MacAusland, M.D., in 1950; and the "Dude from the Back Bay," as Frederick W. Johnson, M.D., was referred to by his associates, introduced the use of rubber gloves in the Carney Hospital operating room—something eccentric enough to label him as unique. Each of these milestones ensures Carney Hospital's place in Boston's medical history and today, as a member of Caritas Christi, the Health Care System of the Archdiocese of Boston, the hospital looks forward to the millennium with renewed optimism in that it will continue the dedication of Andrew Carney and Sister Ann Alexis in providing medical attention to patients of all walks of life, in renewing the hospital's commitment to community-based services, in medical and nursing excellence, and in a spirit of compassion and respect.

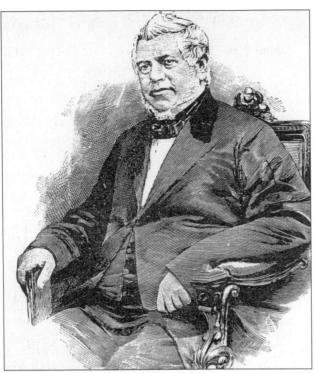

Andrew Carney (1794–1864) was a well-respected man in Boston who liberally contributed to the founding of the Carney Hospital for "relief to the sick poor . . . of all religious denominations." Leaving Ballanagh, County Caven, Ireland, in 1816, he arrived in Boston and worked as a tailor before establishing a partnership with Jacob Sleeper in the ready-made clothing firm of Carney & Sleeper in Boston's North End. His generosity was legendary and he was often referred to as "one of God's best noblemen" and a "kind-hearted, whole-souled, generous friend and protector."

South Boston, Mass. Carney Hospital.

Old Carney Hospital was a large complex on Old Harbor Street on Dorchester Heights in South Boston. Built on site of the old J. Hall Howe Estate, it had panoramic views of Boston and the harbor; it provided necessary health care for patients of all walks of life. In Andrew Carney's own words, it was to be a "hospital where the sick without distinction of creed, color or nation shall be received and cared for."

A benefit "In Aid of Carney Hospital" was held on December 15, 1896, at Horticultural Hall on Tremont Street, opposite the Granary Burial Ground in Boston. The benefit was held to raise necessary funds to continue the good work of the Sisters of Charity at Carney Hospital. In this newspaper sketch from the *Boston Globe*, Isabella Stewart Gardner (often referred to as Mrs. Jack, in regard to her husband John Lowell Gardner) greets other members of Boston's 400 who attended the gala charity event.

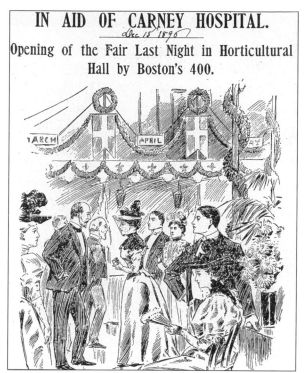

Burdened with lack of available space, the Carney Hospital purchased the former estate of Asaph Churchill (1814–1892) on Dorchester Avenue near Dorchester Lower Mills. The 15-acre estate was adjacent to the Olmstead designed Dorchester Park and had the necessary land for future expansion. Previous to the purchase, the estate had been the site of Boston City Hospital's Convalescent Home, which provided patients with fresh air and a bucolic setting convenient to town. The ground breaking of the new Carney Hospital took place on March 19, 1951, with Archbishop Richard J. Cushing raising $3 million to build a new Carney Hospital.

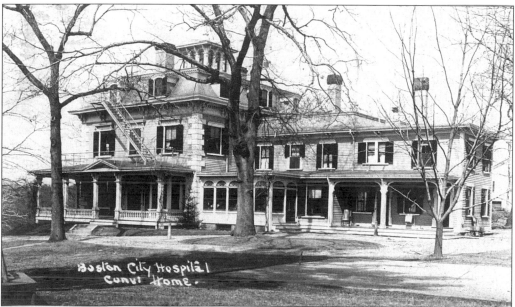

The new Carney Hospital was designed by Kennedy, Kennedy, Keefe, & Carney and was built on Dorchester Avenue between Gallivan Boulevard and the Lower Mills between 1951 and 1953; the new hospital was occupied on December 1, 1953, with 37 patients being transferred by ambulance from the old hospital in South Boston to the new hospital in Dorchester. (Courtesy of the Carney Hospital.)

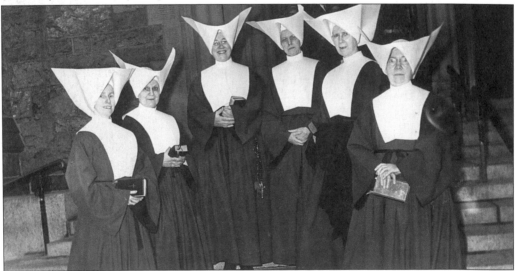

Posing on the steps of the Cathedral of the Holy Cross after a Mass celebrating the 100th anniversary of the founding of the hospital were former administrators of the Carney Hospital in 1963, from left to right, with the year of their appointment, are Sister Margaret Finnegan (1958), Sister Louise Driscoll (1954), Sister Oliva Cunane (1948), Sister Mary Paul Chrismer (1942), Sister Marie Daly (1933), and Sister Electa Stafford (1928). (Courtesy of the Carney.)

A Sister of Charity and a young patient at the Carney Hospital admire his toy steam shovel, c. 1955. The sisters, nurses, and volunteers assisted in the operation of the hospital and in ensuring the comfort of the patients. The Florence Nightingale Pledge stated that "With loyalty will I endeavor to aid the physician in his work and devote myself to the welfare of those committed to my care." (Courtesy of the Carney Hospital.)

An ambulance was stationed at the Carney Hospital to bring patients to the Emergency Room for medical treatment. In exchange for medical services rendered by the hospital, the City of Boston maintained an ambulance station adjacent to the hospital and has made its services available to the hospital for many years. Here, a driver and a medical attendant pose behind the wheel of the ambulance. (Courtesy of the Carney Hospital.)

A Sister of Charity oversees two students from the Laboure School of Nursing (later known as the Laboure Junior College) that were taking special training in public health nursing. This young child seems quite pleased with the attention. In 1951, the Sisters of Charity founded a central school of nursing known as the Catherine Laboure School of Nursing, which was a merger of the schools of nursing at St. Margaret's Hospital, Dorchester, and St. John's Hospital, Lowell. (Courtesy of the Carney Hospital.)

These beaming members of the Ladies of Charity of the Carney Hospital take time from their charitable endeavors on behalf of the hospital for afternoon tea. The Ladies of Charity are the hospital's auxiliary and operate the gift shop. Volunteers assist in the delivery of flowers, books, and mail to patients and host annual fashion shows to raise funds for the hospital. (Courtesy of the Carney Hospital.)

Unit nurse Ruth Ivey R.N. demonstrates the workings of the human heart to hospital patient William Rideout. The teaching of how the heart operates is an integral part of a patient's recovery in the Cardiac Intensive Care Unit, usually answering pressing concerns and questions of the patient and family members. (Courtesy of the Carney Hospital.)

Assisting in the cake-cutting ceremony during the 1978 reception celebrating the Carney Hospital's 25th year in Dorchester were former hospital administrators, from left to right, Sister Oliva Cunan, D.C., Sister Helen, D.C., Sister Frances Michael, D.C., Sister Margaret Finnegan, D.C., His Eminence Humberto Cardinal Medeiros, and Sister Margaret Tuley, D.C. The enormous 450-pound cake was donated for the Carney's silver anniversary by Montillio's Bakery in Quincy. (Courtesy of the Carney Hospital.)

The Seton Medical Office Building was designed by the Aldrich Company, a member of the Carlson Group, and was opened in 1978 and named in honor of St. Elizabeth Ann Seton (1774–1821), the founder of the American communities of the Sisters and Daughters of Charity. A devout convert to Catholicism, Mother Seton's motto was "Blessed are they who wear themselves out for charity." This modern facility, in addition to a multilevel garage, provides office space for members of the hospital medical staff. (Courtesy of the Carney Hospital.)

In 1997, a Recognition Award was presented by Joyce A. Murphy, president of the Carney Hospital, to then Sen. W. Paul White for his Outstanding Dedicated Service to the Health Care Community at the Carney Hospital's Annual Community Dinner. (Courtesy of the Carney Hospital.)

Seven

THE BOSTON HOME

The Boston Home, originally known as the Boston Home for Incurables, was founded in 1881 to "alleviate the problems of permanently disabled persons who could not be cared for in their homes" and whose care was refused in hospitals. A small home was started by Cordelia Harmon, a trained nurse, in Brighton and nine patients were admitted, with a waiting list of 100. However, a year later, with the assistance of Phillips Brooks (1835–1893), Episcopal bishop of Boston, a group of concerned people met to discuss the possibility of expanding the home; the first committee members were Phillips Brooks, chairman; Samuel Eliot; Hamilton Osgood; Roger Wolcott; George Wigglesworth; Mrs. J.S. Copley Greene; Mrs. William Appleton; Mary Ann Wales; and Madeline Mixter. This committee eventually purchased the Codman Farm at the corner of Dorchester Avenue and Codman Street (now Gallivan Boulevard) and adapted it as the second home.

Open to all "classes of the worthy poor without distinction of race or religion," the Boston Home was open to applicants who had incurable diseases such as contagious diseases, cancer, consumption, epilepsy, mental derangement, or any diseases for which special hospitals have been established and by which they were excluded. In 1884, when the home relocated to Dorchester, there were 26 residents—18 female and 8 men. However, by 1887, the capacity of the home was 65 women, men, and children; however, there still remained a pressing need to provide additional space. A capital campaign was launched in 1923 to raise the funds to build a new, modern facility that had spacious quarters which was designed by the Boston architectural firm of Kendall Taylor Company.

The name of the home was officially changed to the Boston Home in 1962, as the term "incurable" often daunted even the best efforts of the staff and volunteers. Since that time, the Boston Home has offered a place where residents afflicted with multiple sclerosis, Parkinson's disease, or lupus can live in relative comfort in a cheerful and supporting environment that allows normal daily living. Today, the Boston Home has residents of all walks of life who meet for movies, videos, book-reading clubs, a horticultural group known as the Green Acres Society, lectures, musicals, and trips to concerts, theatre performances, and museums. With a dedicated staff, and equally committed trustees and volunteers, the residents of the Boston Home lead a contented life as the world passes by on Dorchester Avenue and Gallivan Boulevard.

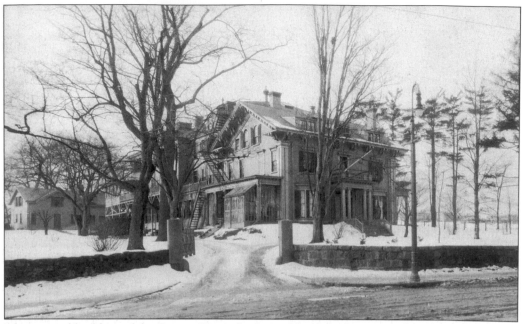

The original building of the Boston Home for Incurables (now known as the Boston Home) was a large Italianate mansion at the corner of Dorchester Avenue and Gallivan Boulevard. The estate was purchased in 1916 through the generosity of Mrs. William F. Weld, trustees of the home, and friends who wished to provide a comfortable and secure home for the residents. In the early years, the home provided care for 26 residents. (Courtesy of the Boston Home.)

Elizabeth Moore was a resident of the Boston Home in the 1920s and was described as a "wholesome, lovable girl . . . gifted above the average, albeit sadly handicapped." Born blind, she became paralyzed after a fall and lived out her life in the comfort and security of the home. Her strength of character, so obvious in the residents of today, allowed her to pursue violin lessons, study French, and maintain an interesting and diverse life— even if it was lived from a wheelchair. (Courtesy of the Boston Home.)

These elderly ladies were often "prisoners of circumstance," in that they were unable to walk and were confined to wheelchairs. An early admission policy to the home was that "preference is given to those of gentle breeding, intelligence, and whose social status is such as to insure some degree of congeniality." (Courtesy of the Boston Home.)

A resident passes through a narrow door frame in the upper hall of the original building of the Boston Home. With strict confines, especially with residents in wheel chairs, the need for a larger and more convenient building by the 1920s was an obvious necessity. (Courtesy of the Boston Home.)

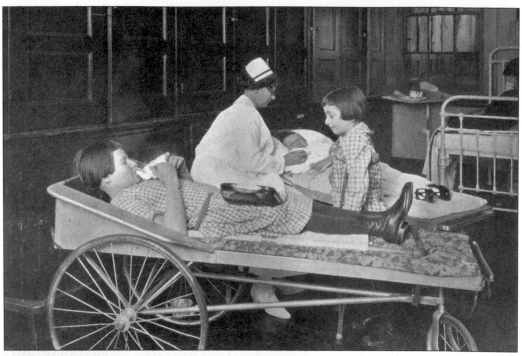

A nurse tends to young residents, who are forced to spend their days on cots that represent their playground as well as their dining table. Though these young residents led seemingly difficult lives, they always appeared happy and had a ready smile for visitors. (Courtesy of the Boston Home.)

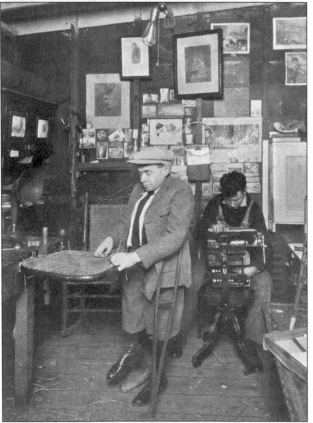

A resident of the Home for Incurables weaves a rush seat in the workshop. Though unable to care for themselves, many residents were able to perform work at the home, which ensured their contributions to society. It was the mission of the home to "help them . . . to lighten the pathway which they are now treading, so that they may be sustained and strengthened by the best which human interpretation of Divine revelation has to offer." (Courtesy of the Boston Home.)

Young residents enjoy an afternoon on the side piazza of the home, c. 1920. The day cots were wheeled out of doors in good weather so that the youngsters could visit with family and friends before their evening meal. An attentive nurse oversees the visitors. (Courtesy of the Boston Home.)

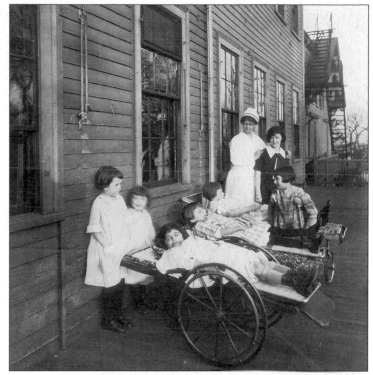

The children's ward at the home had metal-framed beds arranged around the room. Children on either their beds or day cots and genuinely smile for the photographer. (Courtesy of the Boston Home.)

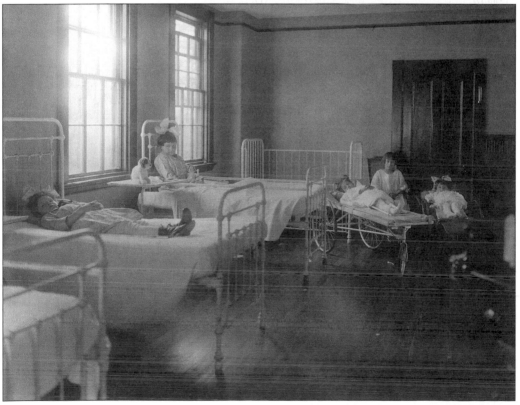

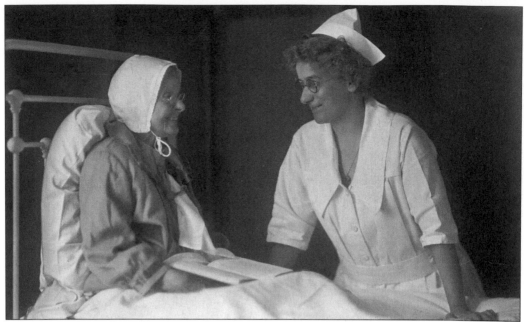

A nurse talks with a resident ready for the evening at the Home for Incurables, c. 1925. Though often afflicted with debilitating circumstances, the residents have always been the reason for the home—and all is done to ensure their continued comfort and happiness. (Courtesy of the Boston Home.)

Two gardeners work in the victory garden behind the home during World War I. Many Americans raised their own vegetables in gardens during both world wars, and in this case, the garden provided fresh vegetables, fruit, and produce to augment the diet of the residents. Notice the tall smokestack in the distance, which belonged to the laundry building. (Courtesy of the Boston Home.)

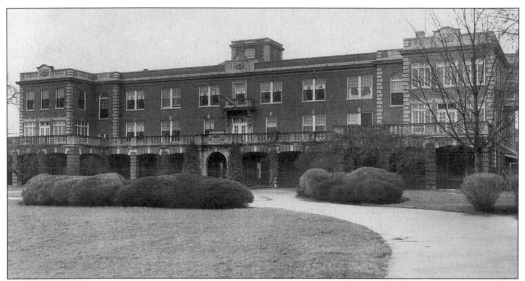

A new building was designed by Kendall Taylor & Company and was built directly behind the original home in 1927. The classically inspired red brick building with flanking projecting wings had a wide terrace with a cement balustrade. (courtesy of the Boston Home)

Members of the Boston Home Board in 1981, from the left to right, are as follows: (front row) David Lewis; Mrs. Russell Hadlock; John H. Gardiner, president of the board; Mrs. Robert Faxon; John V. Woodard; and John B. French; (back row) Robert Minturn, Mrs. J. Armory Jeffries, Kenneth Howe, Anne Shewell, Francis B. Lothrop, Mrs. Richard Barbour, Conover Fitch Jr., Mrs. David B. Tenney, Mrs. Standish Bourne, Thompson Crosby, Mrs. C. Rogers Burgin, Mrs. Edward Wendell, Mrs. James Trumbull, and Mrs. Russell Peverly. (courtesy of the Boston Home)

Discussing patient care at the Boston Home, from the left to right, are members of the medical staff, Robert M. Putnam, M.D.; Cletus A. Carr, administrator of the home; Eugene F. McAuliffe, M.D.; James J. Mahoney, M.D.; Elva G. Proctor, R.N., director of nursing services; and Seth C. Crocker, M.D. (Courtesy of the Boston Home.)

Enjoying her book *Joyful Thoughts for Five Seasons* is Bertha Meserve (1877–1979), a resident of the Boston Home and former head of the English department at the Milton High School. (Courtesy of the Boston Home.)

Residents of the Boston Home took part in the Boston Marathon in 1999. These "Boston Home Wheelers," assisted by faculty and students from Noble & Greenough School, participated in the race and raised funds for computers, speech-recognition equipment, and video-conferencing technology for the home's computer center. Seen here, from the left to right, are Diane LeMay and her companion Jeff Meech, recreation therapist at the Boston Home; Colleen Powers and her companion Fred Sculco, science teacher at Noble & Greenough School; Fred Holoway and his companion Heather Vincent, a student at Noble & Greenough School. (Courtesy of the Boston Home.)

The Green Acres Society at the Boston Home is composed of residents and friends who grow flowers in containers on the terrace overlooking the front entrance. Members of the society, from left to right, are as follows: (sitting) Francine Evans, Marcia Jason, Leighton Bridge, and Helen Christopher; (kneeling) Jean Goldman, recreation therapist at the Boston Home; and (standing) Henry Athanasiou.

The centennial celebrations of the Boston Home included a proclamation citing 1981 as "Boston Home Year" by Gov. Edward J. King. Members of the centennial committee, from left to right, are as follows: (sitting) Mrs. Joseph O. Proctor, chairman of the centennial committee and John H. Gardiner, president of the board; (standing) John Bigelow; Cletus Carr, director; Mrs. Richard B. Chapman; and John V. Woodard. (Courtesy of the Boston Home.)

Shirley Peterson, director of Social Services at the Boston Home, reassures her mother, Mrs. Wheeler, a resident of the Boston Home. (Courtesy of the Boston Home.)

Enjoying Family Day at The Boston Home in 1981 is a resident seated in the center, surrounded by members of her family. Jeannette Lithgow Peverly, standing on the left, is typical of the dedicated members of the board who try to ensure the comfort and happiness of residents. (Courtesy of the Boston Home.)

The Boston Home opened a new wing in 1994, designed by Heym Associates; the addition complimented the original building and provided modern facilities and additional rooms for residents. (courtesy of the Boston Home)

A runner gestures from Grampian Way on Savin Hill toward Boston, c. 1928. The view includes the railroad tracks of both the Elevated Railway (now the Red Line) and the Old Colony Railroad. On the left are three-deckers that face Sydney Street; Telegraph Hill (Dorchester Heights) in South Boston can be seen in the distance, just beyond Carson Beach.

ACKNOWLEDGMENTS

Dorchester, Volume II is a photographic history of the town, which was made possible by the generosity of many people. Numerous residents and friends have shared photographs, memories, and their time to ensure that this is truly a community-wide endeavor. I would like to particularly thank the following for their assistance:

Robin Alsop; Joan Banfield; Anthony Bognanno; Priscilla Hall Bone; Nancy Borden; the Residents of the Boston Home; Paul and Helen Graham Buchanan; Sean Cahill; Mary Jo Campbell; Marta Carney; the Carney Hospital, Joyce A. Murphy, president; Frank Cheney; Elise Ciregna and Stephen Lo Piccolo; Elizabeth Williams Clapp; Clara Clapp; Stephen Clegg; Edie Clifford; Regina K. Clifton; Robert Cohen; Mary G. Connell; Brian DeLacey; Reverend Elizabeth Curtiss; Dexter; William Dillon; Lydia Bowman Edwards; Kevin Farrell; Catherine Flannery; John B. Fox; the late Walter S. Fox; Ardelle Moseley Fullerton; Philip Gavin; Stephen W. Gifford; Joseph Gildea; Jean Goldman; Edward Gordon; Barbara Greene; Roger Greene and Marion Diener; Helen Hannon; James Hobin; Virginia Holbrook; the late Gertrude Hooper; the late Elizabeth Bradford Hough; Kathleen Howley; James Z. Kyprianos; Margaret Lamb; Robert Lamprey; Jane and Phil Lindsay; Diane Loupo; Fred Lyons; Judith McGillicuddy; Robert Mahn of Lawton Vernwood Press; John Franklin May; the Harriet McCormack Center for the Performing Arts; Marilyn Mc Nabb; David and Patricia Mitchell; Susan Navarre; Susan Paine; Rev. Michael Parise; William H. Pear; Shirley Peterson; Jeanette Lithgow Peverly; Loretta Philbrick; Mark Pickering; Daniel Pierce; Roger Pierce; Sally Pierce; Elva Proctor; the late Ruth Raycraft; Dennis Ryan; Marva Serotkin, the Boston Home; Anthony and Mary Mitchell Sammarco; Rosemary Sammarco; Sylvia Sandeen; Robert Bayard Severy; Helen Ruggles Shaw; Joyce Stevens of Heritage Education; Letitia Carruth Stone; Amy Sutton, my patient editor; Anne and George Thompson; the Urban College of Boston; Peter Van Delft; William Vandervoort Tripp; the late Reverend David Venator; William Varrell; the Victorian Society, New England Chapter; Theresa Webber; Virginia White; Susan Williams; the late Marion Woodbridge and Helena Zurbin.